IMAGES
of America

CAPITOL HILL

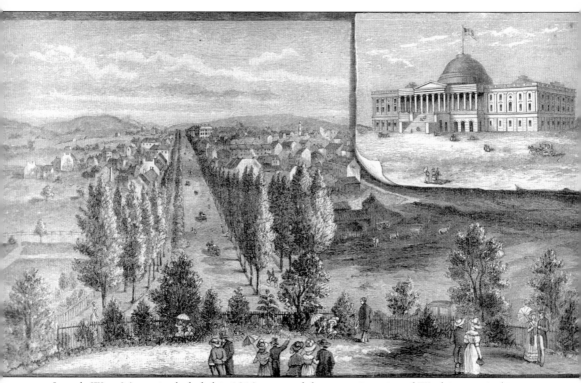

Joseph West Moore included this 1810 scene of the emerging city of Washington in his tome entitled *Picturesque Washington*, published in 1889. It shows the smaller form of the Capitol Building recently completed and Capitol Hill residents overlooking what were then farm fields and livestock. The White House can be seen in the distance, at the end of Pennsylvania Avenue, in the center of the engraving.

IMAGES
of America

CAPITOL HILL

Paul K. Williams and Gregory J. Alexander

ARCADIA

Published by Arcadia Publishing
an imprint of Tempus Publishing Inc.
Charleston SC, Chicago, Portsmouth NH, San Francisco

Printed in Great Britain

Library of Congress Catalog Card Number: 2003115762

For all general information contact Arcadia Publishing at:
Telephone 843-853-2070
Fax 843-853-0044
E-mail sales@arcadiapublishing.com
For customer service and orders:
Toll-Free 1-888-313-2665

Visit us on the internet at http://www.arcadiapublishing.com

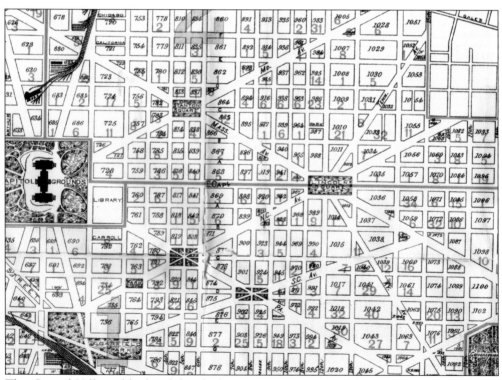

This Capitol Hill neighborhood detail of an 1894 map was issued by the D.C. Department of Health to illustrate the number of outdoor privies, or outhouses, located within each block. Square designations are noted with small numerals, and the number of privies per square is recorded in large numerals.

CONTENTS

ACKNOWLEDGMENTS

This book certainly would not have possible without the assistance of our editor at Arcadia Publishing, Susan E. Beck. Thanks must also go to Arni Einarsson, whose "Room with a View" apartments in Reykjavik, Iceland, provided the perfect isolation and breathtaking vistas that would inspire any writer. Also, acknowledgment must be made to traveling companions Heather and Marshall Hoöffenflöögan-Perkins, who helped inspire us and deciphered our freakazoides. The Blue Lagoon spa outside of town provided the ultimate in relaxation and book-writing tension relief.

This volume and the historical tidbits herein are dedicated to the late historian Ruth Ann Overbeck, a Capitol Hill resident and history expert who loved nearly every aspect of Hill life.

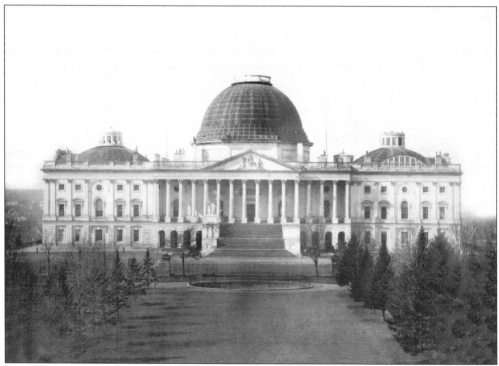

One of the earliest known photographic images of the Capitol Building, from which the neighborhood derives its name, is this 1846 image taken by John Plumbe Jr. It was discovered at a California flea market in 1973 but is now part of the collection of the Library of Congress. The image shows the Capitol with the outer wooden dome designed by Charles Bulfinch. The dome was replaced in 1851.

INTRODUCTION

As one of the nation's largest historic districts, Capitol Hill is a neighborhood rich in history. Beginning as a port area on the high plateau near the deep waters of the Anacostia River, Capitol Hill was largely shaped by early residential development near the Navy Yard. Later home to middle class workers in the late 19th century, Capitol Hill is now one of Washington's most elite neighborhoods with more senators and congressmen residing there than any other neighborhood in the entire country. The authors hope to expose the reader not to a comprehensive history of the vast neighborhood, but rather offer glimpses into its unique and rich historical past with vintage photographic selections from both familiar and undiscovered aspects of Capitol Hill's past.

Chapter one explores the early development of Capitol Hill, a neighborhood situated on the highest point of land between the Anacostia and Potomac Rivers and originally consisting of a small cluster of homes located at First and Second Streets along New Jersey Avenue SE. This chapter will take the reader from the early grand estates such as the Belmont-Sewell House, Duddington Manor, and The Maples, to the neighborhood's changing landscape due to the outbreak of the Civil War when homes were converted to boarding houses and hospitals.

In chapter two, the awesome influence of the nation's military on Capitol Hill is discussed with particular emphasis on the Navy Yard and the Marine Barracks, both of which call Capitol Hill home. The Navy Yard has had a profound effect on Capitol Hill, beginning with the site selection at the close of the 18th century, President Jefferson's designation of the area as the U.S. Navy's home port, and its participation during the Spanish-American War. The neighborhood's employment structure was also profoundly influenced by the Navy Yard's presence. The Marine Barracks' history began around the beginning of the 19th century, and the land was later occupied by the British in 1814. The influence of World Wars I and II will also be discussed in this chapter.

Chapter three will show how the commercial and religious arenas have helped shaped Capitol Hill's history. Although many places of worship exist in this neighborhood—all with fascinating histories—special attention is given to Christ Church, Congressional Cemetery, and St. Mark's Episcopal Church. Likewise, the commercial aspect is briefly discussed through influential hotels, apartments, and retail operations. This chapter also pays homage to the early health care facilities, including Providence Hospital and Casualty Hospital. Providence Hospital, with roots back to 1872 as one of Washington's oldest hospitals, has resided in three structures, two of which were in Capitol Hill. Through an examination of historic photos of these buildings and the activities within, Providence Hospital comes to life again.

Community life is the focus of chapter four. Although a broad subject, this chapter will focus on community services, such as the many fire stations, as well as historical structures, such as Eastern Market. From its inception in 1873 as part of a city-wide public market system to provide residents with an array of goods and services, Eastern Market—unlike many of its counterparts—still thrives today. Also explored in this chapter is the ever-changing residential makeup of Capitol Hill. Its early residential history consists of modest homes built for middle-class families and employees of the Navy Yard with varied success by developers and builders, as

well as Capitol Hill's interesting and haunting alley slums of the early 1900s. Both the move of many residents to the suburbs and the panicked escape from the district after the riots following the assassination of Marin Luther King Jr. caused Capitol Hill to experience a decline in quality of life for its remaining residents until a surge starting in the 1980s saved the neighborhood from further decline.

Chapter five traces the history of the many transportation methods that had an effect on Capitol Hill. The Baltimore & Ohio Railroad and the streetcar systems are some the earlier ones shown in this chapter, while the majority of the chapter is dedicated to the history of Union Station, one of the neighborhood's—and the city's—most noteworthy structures. Union Station's inception in the early-20th century and its influence on the railroad system in Washington, D.C., are discussed, as well as the competing design desires by the architect, the government, and the railroad companies. Through an array of historical photographs, Union Station's changing landscape and its importance, especially during wartime, receive special attention in this chapter.

In this book, the authors hope to explore the rich history of one of Washington's most well-known neighborhoods through historical photographs, interesting stories, and informative text. In accordance with the style and format of Arcadia Publishing's *Images of America* series, this book's goal is to offer a glimpse into the history of Capitol Hill and not serve as a comprehensive history of this neighborhood, as no one book could do Capitol Hill's rich history proper justice.

One
EARLY DEVELOPMENT

The early development of Capitol Hill was greatly influenced by its proximity to the Anacostia River, which the city had hoped would support a significant port. One of the early grand estates was located at 144 Constitution Avenue NE; built in 1772 by Lord Baltimore as a wedding gift to his daughter, the home was burned by the British in 1814 but was rebuilt by Robert Sewell. It gained historical significance when President Jefferson's Secretary of State Albert Gallatin resided there, and the papers for the Louisiana Purchase were signed in the living room. Known as the Belmont-Sewell House, it is now occupied by the National Women's Party.

Another early home was Duddington Manor at First and F Streets SE; it was completed in 1797 and was the home to one of the largest landowning families in Maryland, the Carroll family, who resided at the six-acre estate for generations. Visitors to the estate included Presidents Washington, Adams, Jefferson, Madison, and Jackson. Other early developments include The Maples, at 630 South Carolina Avenue SE, which can trace its origins to 1796, and Tunnicliff's Eastern Branch Hotel on Pennsylvania Avenue between Eighth and Ninth Streets SE, which opened in the fall of 1796 and was still standing as late as 1925.

However, the first neighborhood called "Capitol Hill" was a small cluster of homes located at First and Second Streets along New Jersey Avenue SE around 1800. Since few Congressmen preferred to establish permanent residence in the city during the early years of the Republic, they chose instead to rent rooms in one of the numerous boarding houses located within walking distance of the Capitol. Carroll Row was constructed in 1805 and a home there served as a boarding house where Abraham Lincoln lived as a Congressman in 1847 and 1848. The advent of the Civil War caused many homes on Capitol Hill to serve as hospitals and boarding houses.

Although new construction was rare during this time, a part of Eleventh Street SE was developed with an interesting story. Several versions exist of how the 100 block of Eleventh Street SE became known as Philadelphia Row, but it is generally accepted that the developer of the block, Charles Gessford, had the homes built for his wife, a native Philadelphian, so that she could recall her hometown.

This panoramic view from the top of the Capitol Building shows the old Brick Capitol in the foreground at right, located between First and Second Streets. The street seen at top is Maryland Avenue.

This early 18th century view of New Jersey Avenue and B Street, site of the Coast & Geodetic Survey Building, shows the rather rural nature of the area, with many roads remaining unpaved until the Boss Shepherd civic improvements of the 1870s. The sketch appeared in the *Washington Evening Star* on December 16, 1902.

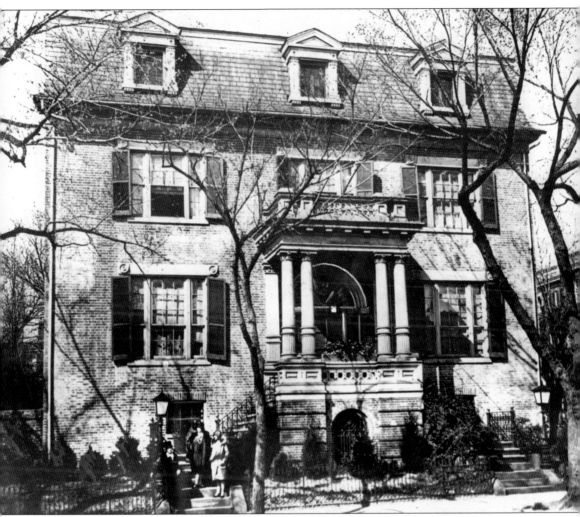

The origins of this house at 144 Constitution Avenue NE can be traced to 1772, when it was built by Lord Baltimore as a wedding gift to his daughter. Burned by the British in 1814, it was rebuilt years later by Robert Sewell. Jefferson's Secretary of State Albert Gallatin resided here, and the papers for the Louisiana Purchase were signed in the living room. Later owner Sen. Porter Dale of Vermont offered the house to its current occupants, the National Women's Party. Since Alva Belmont provided the funds for its purchase from Dale, the home is known as the Belmont-Sewell House.

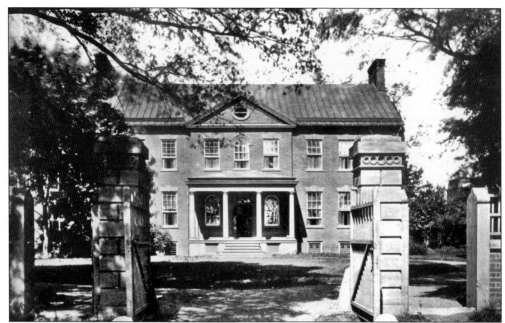

Duddington Manor at First and F Streets SE was occupied by 1793, although it was not completed until 1797, when architect Benjamin Latrobe finished the design of the house. The Carroll family had come to Maryland in 1680 and eventually became one of the largest landowners in the state. Daniel Carroll and his family remained at the six-acre estate for generations to come. The entire estate was enclosed at its borders with a brick wall and received visitors recorded to include Presidents Washington, Adams, Jefferson, Madison, and Jackson.

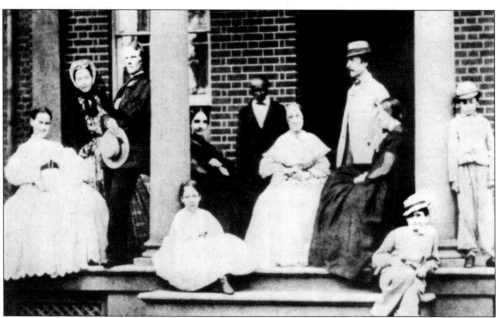

Family members of Daniel Carroll gathered on the steps of Duddington, the family mansion, for this rare photograph in 1862. Across the street from this site, in the 100 block of F Street, currently is an area known as Garfield Park, named after President Garfield.

Daniel Carroll died in 1849, but his daughter continued to live at Duddington until the late 1880s, when the house was sold for $60,000. It then suffered the same fate that cursed its original location: Heckman Street was cut through the estate and plans called for developing the two portions of the block into townhouse development. The manor home remained on a much smaller lot until being demolished in 1886, when many of the present-day homes were built about its perimeter, including the entire 100 block of F Street, in 1898. Duddington's main staircase, seen here, was moved to the Thompson House at 820 Seventeenth Street NW, when it was photographed by John O. Brostrup on January 9, 1937.

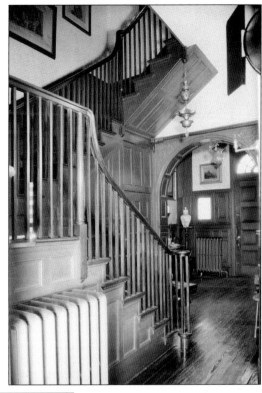

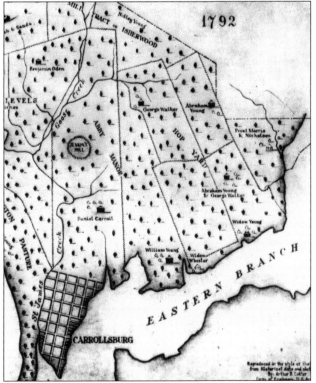

This 1792 map shows the land that originally belonged to Daniel Carroll, along with others that were located to the east of Jenkins Hill (site of the Capitol). The construction of the Duddington Manor estate began in 1791 by Daniel Carroll, a proprietor of lands crucial to the planning of the federal city, on what is today Square 736, at First and F Streets SE. He had originally begun construction of a house nearby where architect Pierre L'Enfant insisted New Jersey Avenue be constructed. An indignant L'Enfant ordered the construction of Duddington Manor halted and had the foundation destroyed, with the ensuing fight solved by George Washington and three local commissioners, who offered a $4,000 indemnity to make up for Carroll's losses.

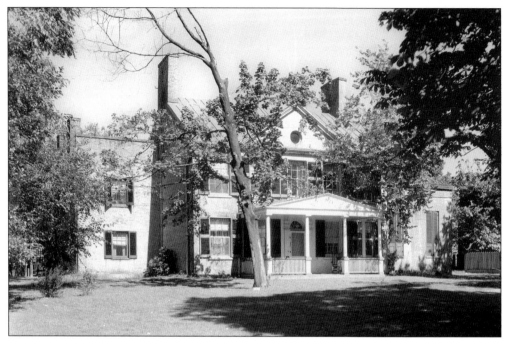

Origins of The Maples, at 630 South Carolina Avenue SE, can be traced to 1796, when major portions of the house were built by tobacco planter William Mayne Duncanson. It was then known as Maple Square. The east wing once featured walls and ceilings painted by Constantino Brumidi. The home was documented as part of the Historic American Buildings Survey by photographer Albert S. Burns on October 31, 1935.

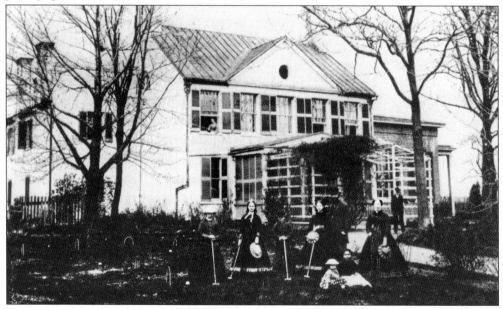

The Maples was purchased in 1815 by Francis Scott Key, author of the "Star Spangled Banner," and then purchased by Sen. John M. Clayton of New Jersey in 1858, who added the east ballroom. These elegant croquet players are photographed on the lawn of the house about the time it was owned by journalist Emily Edson Briggs, who wrote under the pseudonym "Olivia."

The severe interior damage of The Maples was photographed by Albert S. Burns of the Historic American Buildings Survey in September 1935. This image shows the damage to Constantino Brumidi's ceiling paintings in the east ballroom, built by Senator Clayton in 1858.

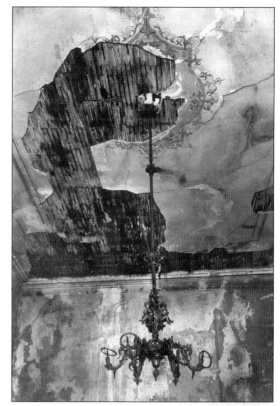

The Maples was expanded once again by Emily Briggs, who also installed its carved marble mantles. In 1936, the house was redesigned for institutional use by architect William Lovering; it became known as Friendship House, a Quaker center for social work.

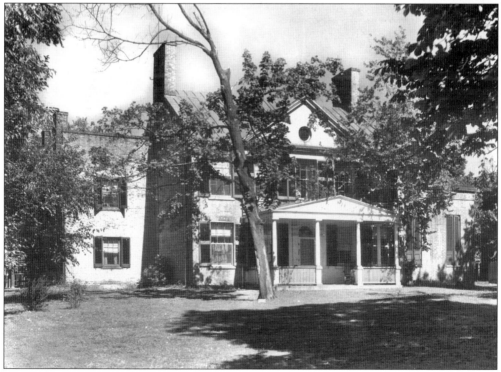

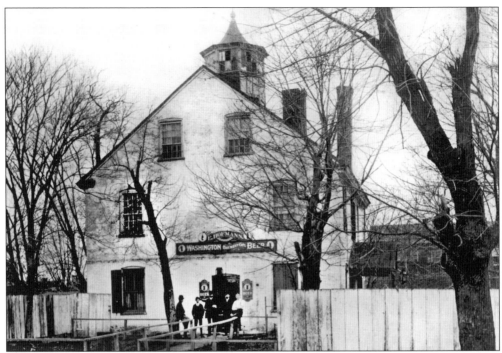

Tunnicliff's Eastern Branch Hotel stood on Square 925 on Pennsylvania Avenue between Eighth and Ninth Streets SE. It opened in the fall of 1796 and was still standing as late as 1925. At the time this picture was taken, it was owned and operated by E. Hoffmann, who proudly served beer from the Washington Brewery Companies.

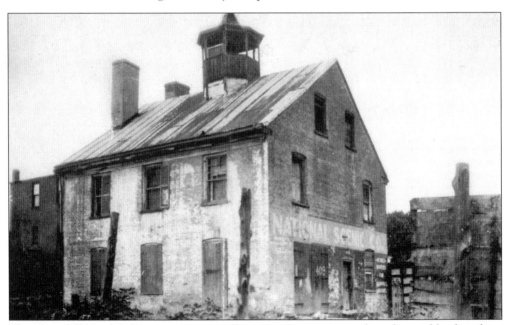

The Turncliff Hotel & Tavern was especially convenient, as it stood on the road leading from the upper Eastern Branch ferry. In December 1896, the Washington Dancing Assembly was held here, the earliest affair of the sort. Known as the oldest hotel in the city, it opened in 1796.

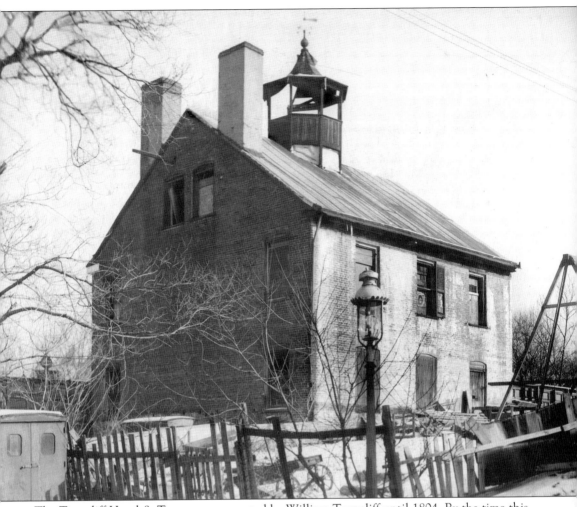

The Turncliff Hotel & Tavern was operated by William Turncliff until 1804. By the time this photograph appeared in the December 6, 1927 *Washington Post*, the building had fallen on hard times. It has since been demolished.

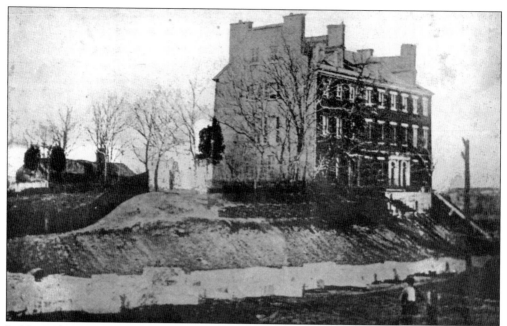

In November 1800, when only the north wing of the Capitol had been completed, both houses of Congress moved to Washington, and Capitol Hill was almost immediately the center of attention for developers. George Washington himself had these two houses built on North Capitol Street between B and C Streets NE. The blocks of marble on the street were used in the construction of the Senate wing of the Capitol. This crude photo was taken in 1861 by Civil War officers quartered in the Capitol.

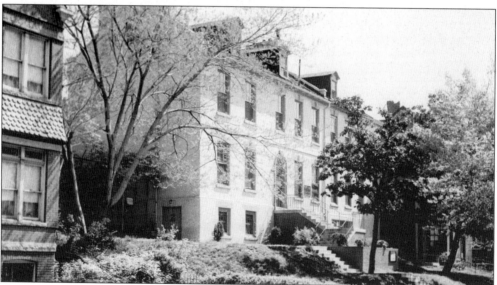

The houses once located at 324 and 326 Virginia Avenue SE were built in 1800 by Dr. Frederick May. They were later owned and occupied by Col. Samuel Nichols Smallwood, twice mayor of Washington, from June 14, 1819, to June 14, 1822, and from June 14, 1824, to his death on September 30 of that year. The homes were documented by the Historic American Buildings Survey; Russell Jones photographed them in April 1959.

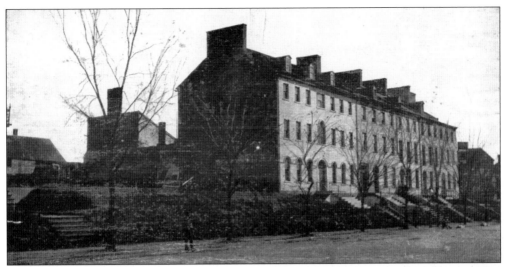

The impressive row of homes once located across the street from the Capitol Building on First Street, between A and East Capitol Streets SE, were known as Carroll Row, after their builder Daniel Carroll constructed them in 1805. They provided a convenient location as a rooming house for the invading British soldiers in 1814.

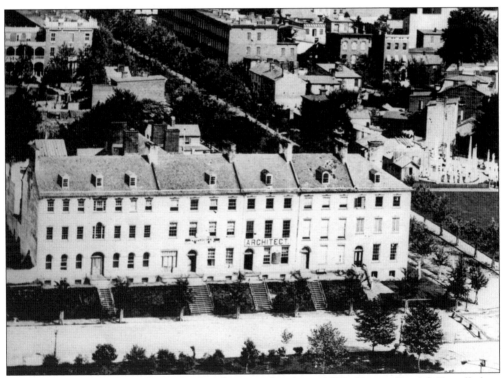

Carroll Row was built in the Federal architectural style in 1805. Owner Daniel Carroll then lived at Duddington Manor at nearby First and F Streets SE. The large structure at the left later served as a tavern and the third house from the right served as a boarding house where Lincoln lived as a Congressman in 1847 and 1848. The row was torn down on November 5, 1886, to clear the site for the main Library of Congress building.

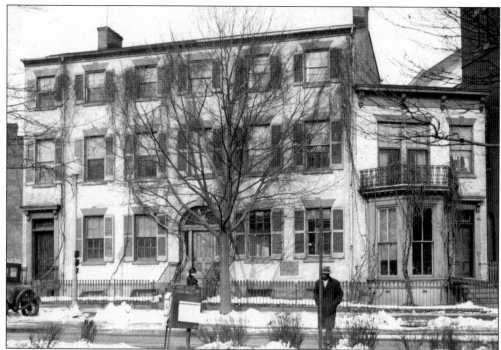

The Elias Boudinot Caldwell House at 204-208 Pennsylvania Avenue SE served as the temporary location of the Supreme Court, which was forced to hold sessions here after the original court building was burned by the British in 1814. Caldwell was then a clerk at the court. The house is pictured here on January 27, 1930.

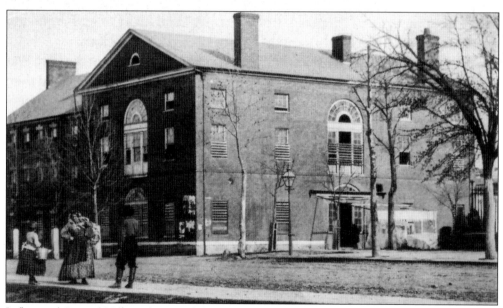

Influential Capitol Hill residents and developers financed this brick structure to house Congress and encourage the federal government to remain in Washington. It served in that capacity from 1815 to 1819, while the Capitol Building was being rebuilt. During the Civil War, it served as the Capitol prison, located on the current site of the Supreme Court building.

These houses represent the typical style of Capitol Hill houses in the early 19th century; these fine examples were built at 1000 and 1002 Independence Avenue.

The house that once stood at 711 Sixth Street SE near G Street was built in 1830 by Isaac Pierce, owner of Pierce Mill, a historic site currently located in Rock Creek Park. John O. Bostrup took this picture on December 23, 1936, shortly before the building was razed, as documentation for the Historic American Building Survey.

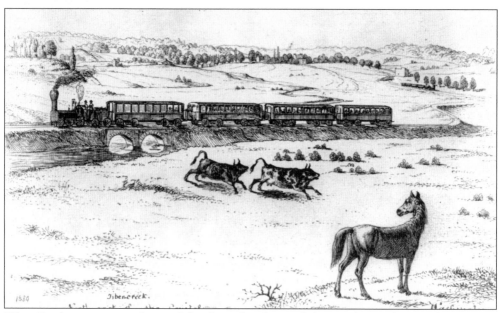

Tiber Creek once ran northeast of the Capitol and provided water for residents and animals in the first few decades of the 19th century. This image of the creek with an arriving train was sketched by Augustus Kollner in 1839.

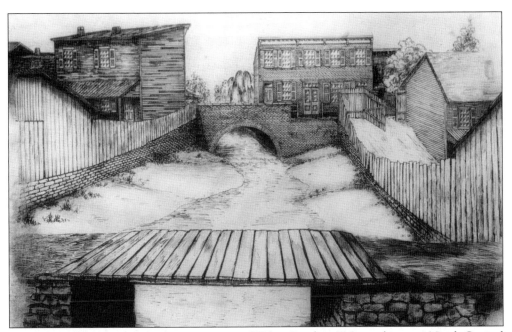

An elegant old stone arch bridge once spanned Tiber Creek at H Street between North Capitol Street and First Street NE. The house on the left was the Hogan's Home, and the two in the background are the Corridon's Old Homes, which were still standing in 1922. The arch on the bridge was torn down when the creek was filled in 1876.

Although several versions exist of how the 100 block of Eleventh Street SE became known as Philadelphia Row, it is generally accepted that the developer of the block, Charles Gessford, had the structures built for his wife, a native Philadelphian. According to Stuart E. Jacobson, "to stave off his young wife's homesickness for her native Philadelphia, [Gessford] took her to Europe while he erected, across from their Capitol Hill home, rowhouses in the style of those in her home town. They returned to Washington late in the night, and when she looked out her window the next morning, she saw Philadelphia." Gessford partnered with carpenter Stephen Flanagan to construct the row, across the street from his own home, between 1865 and 1867.

By constructing many homes simultaneously, builders like Gessford could conserve funds by ordering architectural elements in bulk, such as the basement window grates found along Philadelphia Row. He continued to develop many blocks on Capitol Hill throughout the following decades, including the home at 123 Fourth Street SE, those in the 200 block of Eleventh Street SE, those from 638 to 642 East Capitol Street in 1890, those from 200 to 208 Tenth Street in 1891, and those from 824 to 832 D Street in 1892.

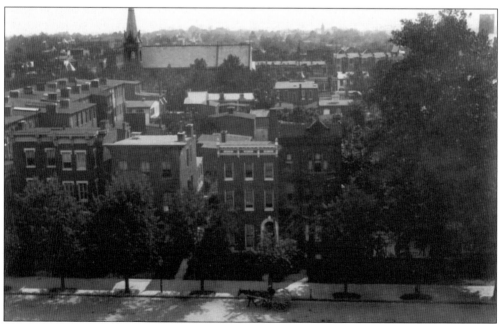

This rooftop view from Capitol Hill shows the heavily developed status of the neighborhood around the turn of the 20th century.

Two

MILITARY INFLUENCE

Like many neighborhoods in Washington, D.C., Capitol Hill has been shaped by the importance of the nation's military, and the presence of the Navy Yard and the Marine Barracks add greatly to the military's influence of this area.

A 12-acre site for the Navy Yard was selected at the close of the 18th century, and by 1803, President Jefferson designated the area as the home port for the United States Navy and the depository for all vessels in its fleet. One of the first buildings developed in the Navy Yard was the Commandant's House, built in 1801, which has served continuously as the Commandant's home ever since.

The Navy Yard was significantly expanded in the 1840s and 1850s with several large industrial buildings forming a quadrangle, and by 1886, all shops had turned to ordinance production. The United States Naval Gun Factory housed the production of heavy weapons, and the weapons plant saw significant activity in 1898 during the Spanish-American War. The Navy Yard continued to employ hundreds of Capitol Hill residents throughout the decades, becoming the most important manufacturing establishment of 19th-century Washington. The plant continued in this capacity until 1962.

The site for the Marine Barracks was first scouted in June 1800; however, British troops made these barracks their headquarters during the occupation in 1814. The first main building to be constructed did not occur until 1834 when a hospital was built with quarters for enlisted men located upstairs. The Marine Barracks also featured a Commandant's House at 801 G Street SE, built in 1806 on a site selected by President Thomas Jefferson. It has housed every Marine Corps Commandant since and was significantly expanded in 1840.

World War I changed the landscape of Capitol Hill when temporary housing for the female workers who poured into Washington was built hastily on the east side of Union Station. Female defense workers bunked in these dormitories when Washington was ill-prepared for such an influx of new workers. Although government employment declined in the 1920s, these dormitories survived until 1931, when they were torn down to expand the Union Station Plaza. World War II also saw the construction of temporary housing around Capitol Hill.

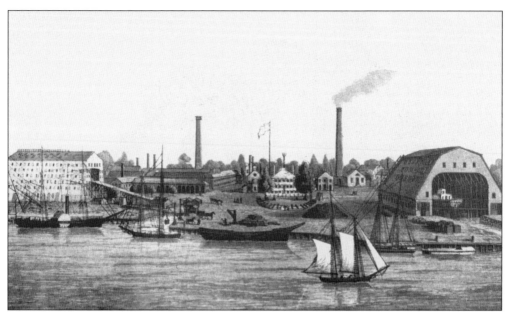

The Navy Yard is illustrated here in an early lithograph by E. Sache & Company of Baltimore, Maryland. The large sugar refinery, at left, was erected in 1797 but razed by 1847.

The interior of the Navy Yard is seen here; this is part of the original, 12-acre site selected and begun in 1799 as one of the country's first naval installations. It was developed enough by 1803 to be designated by President Jefferson as the home port for the United States Navy and the depository for all vessels in its fleet.

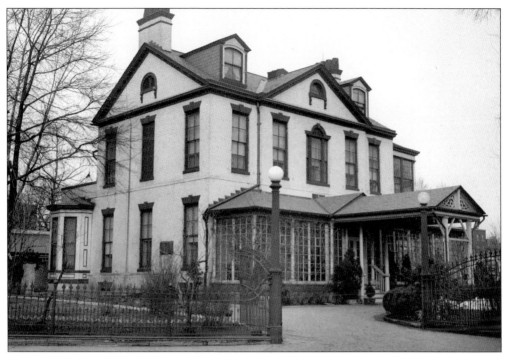

The Commandant's House at the Navy Yard was built in 1801 by Thomas Tingey, the first Commandant of the Yard. It has served continuously in that capacity ever since. Several large additions were made in the mid-19th century with Victorian-era expansions and remodeling apparent. This Historic American Buildings Survey photograph was taken on February 25, 1936, by Delos H. Smith.

The other side of the Commandant's House is seen in this Historic American Buildings Survey photograph by Delos H. Smith. It was spared demolition by the British in 1814. Its first inhabitant, Capt. Thomas Tingey, witnessed the humble beginnings of the base in 1799 and its complete formation as a major naval facility by the time of his death in 1829.

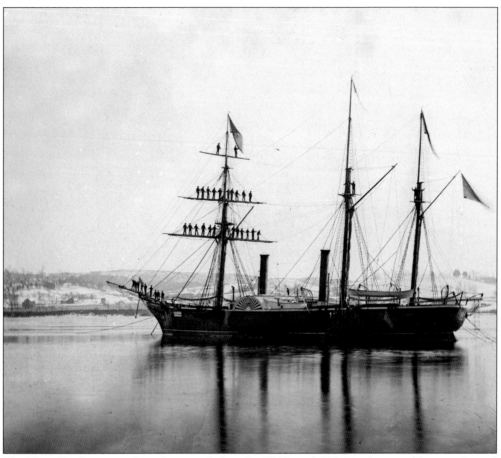

The Navy Yard was significantly expanded in the 1840s and 1850s with several large industrial buildings forming a quadrangle. This picture captures a Brazilian Steam Frigate at the yard in January 1863; the photo was taken on the occasion of the President's visit. Photograph by Alexander Gardner.

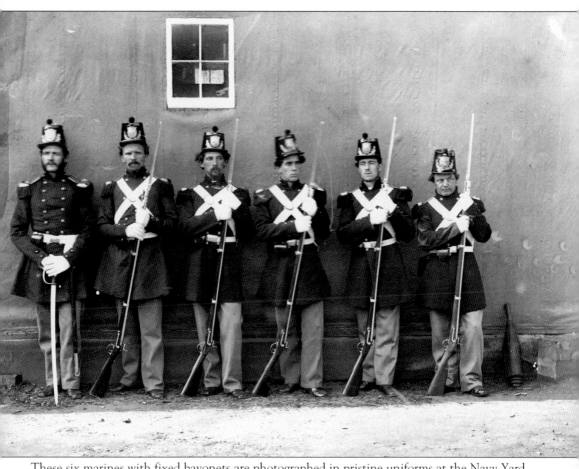

These six marines with fixed bayonets are photographed in pristine uniforms at the Navy Yard about 1864.

Three early houses were built on the Navy Yard by 1803, including the Commandant's House and Quarters "B." Neither is attributed to famed architect Benjamin Latrobe, although he began working for the installation in 1804, initiating his city plan and laying the ground work for reclaiming the surrounding swampy ground into additional space for the U.S. Navy.

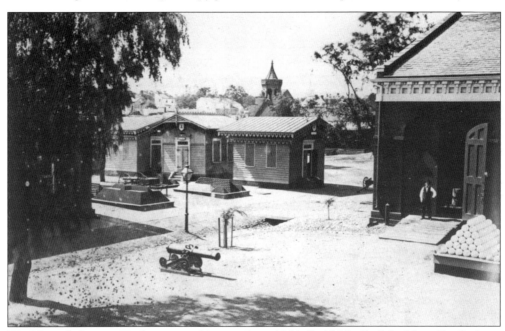

The Navy Ordinance Yard is pictured here in June 1866. By 1886, all of the Navy Yard's shops were turned over to the production of ordinance. This photograph was taken by the famous firm of Matthew Brady & Company.

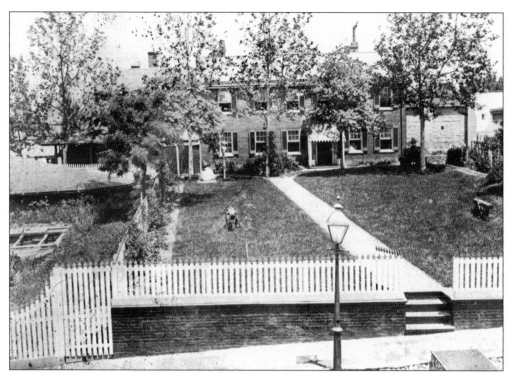

An officer's house at the Navy Yard is pictured here in June 1866 by Matthew Brady & Company. Largely under the guidance of the 1804 city plan by Benjamin Latrobe, officer's quarters and several large industrial buildings were built between 1804 and 1814.

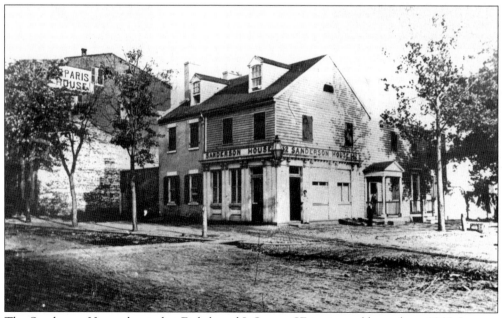

The Sanderson House, located at Eighth and L Streets SE is pictured here about 1866. It was a restaurant that was popular due to its location near the main gate of the Navy Yard. Photograph by Joseph E Bishop.

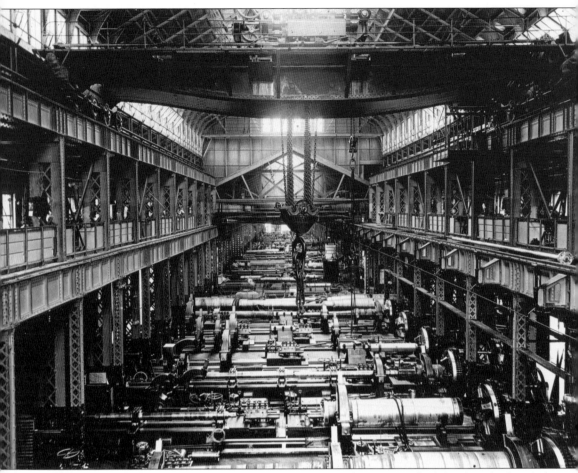

The gun factory at the Washington Navy Yard is pictured in 1903. All of the shops had turned to ordinance production by 1886, reflecting a decision two years prior to establish the United States Naval Gun Factory at the Washington Navy Yard. Production of heavy weapons was done in several different massive production facilities.

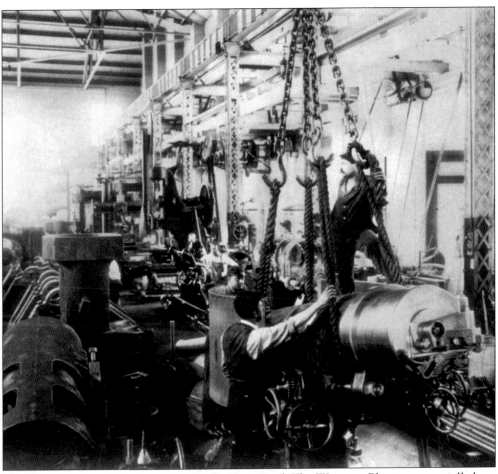

Mechanics are at work on a new gun at the Navy Yard. The Weapons Plant was especially busy in 1898 during the Spanish-American War.

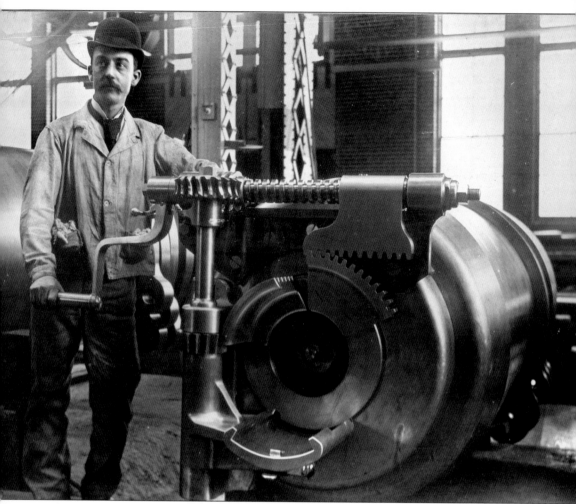

The Navy Yard employed hundreds of Capitol Hill residents throughout the decades, becoming the most important manufacturing establishment of 19th-century Washington. The plant continued in this capacity until 1962.

This intriguing photograph was taken of two nurses with their lawyers in 1925. The nurses were tried that year by a General Navy Court for smuggling liquor into the United States at the Navy Yard.

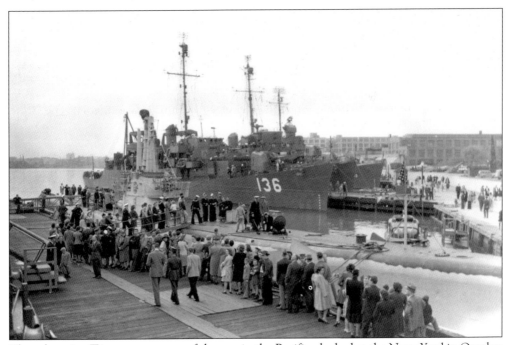

The submarine Tirante, a veteran of the war in the Pacific, docked at the Navy Yard in October 1945. Since the 1960s, the Navy Yard has served primarily as a Naval Administrative Center.

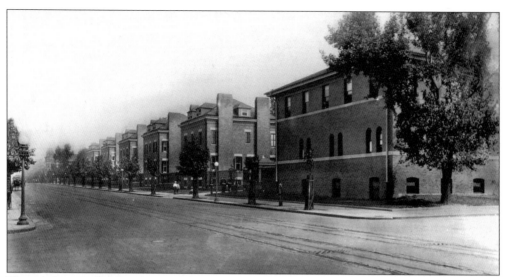

The newly completed exterior of the Marine Barracks was photographed from Eighth Street around the turn of the century. The site was first scouted in June 1800 by Quartermaster Lieutenant Robert Rankin; a few buildings were constructed shortly thereafter; however, the first main building, a hospital with quarters for enlisted men located upstairs, was not constructed until 1834.

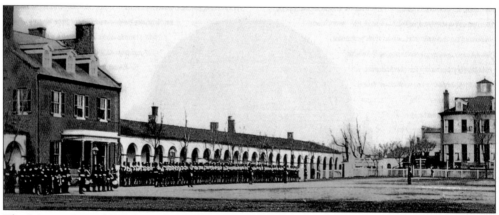

The Marine Barracks and Parade Ground at Eighth and I Streets SE is seen here about 1859. Old Center Building (left) was built in 1801 and torn down in 1907. The Commandant's House (right) was built in 1806. British troops made these barracks their headquarters during the occupation in 1814.

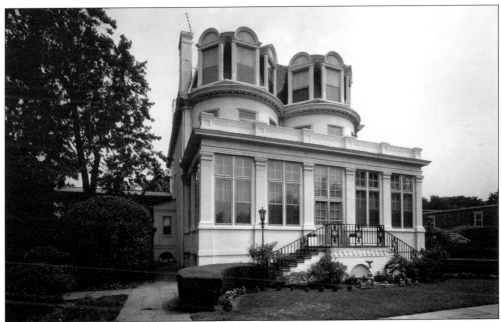

The Marine Corps Commandant's House at 801 G Street SE was built in 1806 on a site selected by President Thomas Jefferson; it has housed every Marine Corps Commandant since. It was significantly expanded in 1840 and a Mansard-styled roof designed by the Hornblower & Marshall architectural firm was added in 1891. The porch was enclosed in 1907. This Historic American Buildings Survey photograph was taken in 1974.

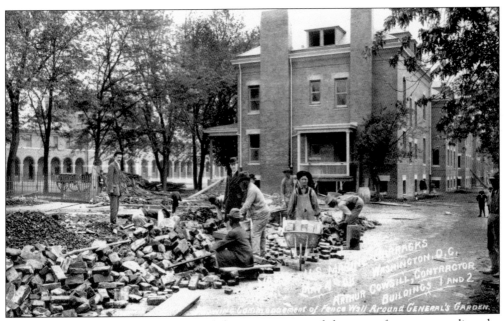

This picture captures the beginning of the construction of the stone fence surrounding the general's garden at the Marine Barracks on May 4, 1908. Two supervisors from the Arthur Cowsill construction company watch workers, while two children, far right, can be seen with a curious eye toward the photographer.

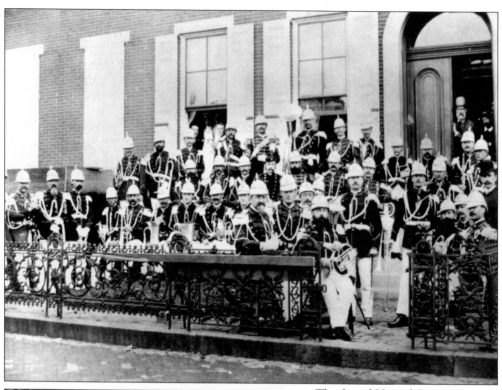

The famed United States Marine Corps Band is pictured in Albany in 1888. The band was led by famous composer and musician John Philip Sousa for many years.

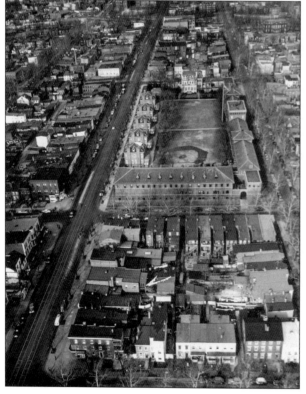

This aerial shot of the Marine Barracks, looking north, shows its close proximity to surrounding residential areas; the Commandant's House can be seen at the north end in the center. This photograph appeared in the *Washington Star* on March 4, 1951.

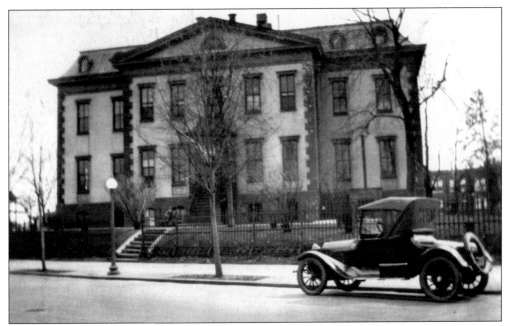

When this image was taken in 1930, the Old Naval Hospital served as the United Spanish War Veterans Headquarters and the Soldiers and Sailors Temporary Home. Its fate languished as an underutilized city-owned property for decades before the Friends of the Naval Hospital organization was formed to document its history and create a plan for its continued preservation.

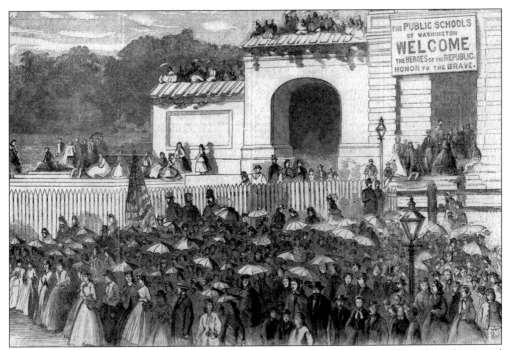

This engraving shows public school children gathered on the steps of the Capitol for the Grand Review, a parade of soldiers returning from the Civil War. This image appeared in the June 10, 1865 edition of *Harper's Weekly*.

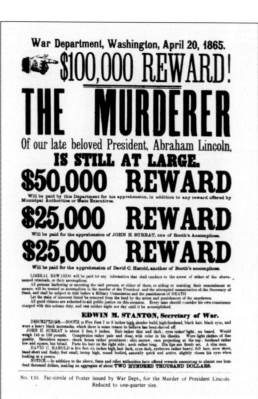

War Department, Washington, April 20, 1865.

$100,000 REWARD!

THE MURDERER

Of our late beloved President, Abraham Lincoln,

IS STILL AT LARGE.

$50,000 REWARD

Will be paid by this Department for his apprehension, in addition to any reward offered by Municipal Authorities or State Executives.

$25,000 REWARD

Will be paid for the apprehension of JOHN H. SURRAT, one of Booth's Accomplices.

$25,000 REWARD

Will be paid for the apprehension of David C. Harold, another of Booth's accomplices.

LIBERAL REWARDS will be paid for any information that shall conduce to the arrest of either of the above-named criminals, or their accomplices.

All persons harboring or secreting the said persons, or either of them, or aiding or assisting their concealment or escape, will be treated as accomplices in the murder of the President and the attempted assassination of the Secretary of State, and shall be subject to trial before a Military Commission and the punishment of DEATH.

Let the stain of innocent blood be removed from the land by the arrest and punishment of the murderers.

All good citizens are exhorted to aid public justice on this occasion. Every man should consider his own conscience charged with this solemn duty, and rest neither night nor day until it be accomplished.

EDWIN M. STANTON, Secretary of War.

DESCRIPTIONS.—BOOTH is Five Feet 7 or 8 inches high, slender build, high forehead, black hair, black eyes, and wore a heavy black moustache, which there is some reason to believe has been shaved off.

JOHN H. SURRAT is about 5 feet, 9 inches. Hair rather thin and dark; eyes rather light, no beard. Would weigh 145 or 150 pounds. Complexion rather pale and clear, with color in his cheeks. Wore light clothes of fine quality. Shoulders square; cheek bones rather prominent; chin narrow, ears projecting at the top; forehead rather low and square, but broad. Parts his hair on the right side; neck rather long. His lips are firmly set. A slim man.

DAVID C. HAROLD is five feet six inches high, hair dark, eyes dark, eyebrows rather heavy, full face, nose short, hand short and fleshy, feet small, instep high, round bodied, naturally quick and active, slightly closes his eyes when looking at a person.

NOTICE.—In addition to the above, State and other authorities have offered rewards amounting to almost one hundred thousand dollars, making an aggregate of about TWO HUNDRED THOUSAND DOLLARS.

No. 130. Fac-simile of Poster issued by War Dept., for the Murder of President Lincoln.
Reduced to one-quarter size.

This poster offered rewards for the capture of John Wilkes Booth, John H. Surrat, and David C. Harold; a national hunt was on for anyone involved with the Lincoln assassination. Several conspirators were held at the old brick Capitol Building on the site of today's Supreme Court.

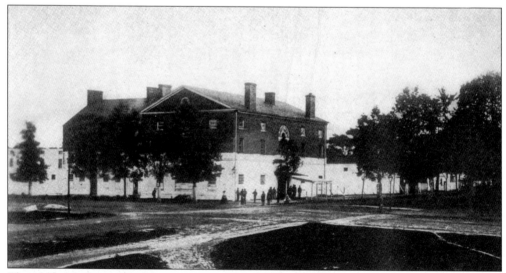

The old brick Capitol Building, constructed in 1815, became the Capitol Penitentiary during the Civil War, housing hundreds of Southern soldiers. It was also where the Lincoln conspirators were held before being executed at the arsenal. Located on what is today the Supreme Court building, it was torn down in 1869.

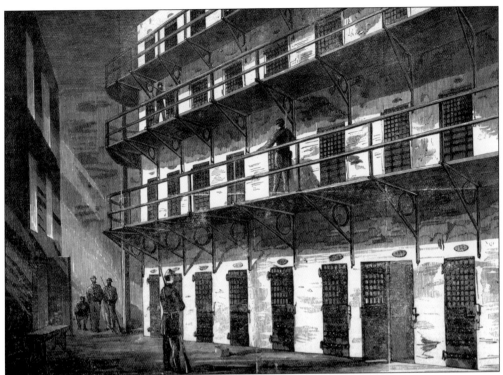

This exterior view of the cellblock shows where the Lincoln conspirators were held in the Old Penitentiary building. This sketch appeared in *Harper's Weekly* magazine in what was certainly the most scandalous story of 1865.

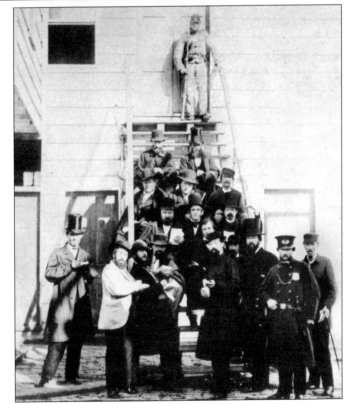

The newspaper correspondents covering the Lincoln conspirators' hanging gathered outside the Washington Arsenal for this picture on November 10, 1865.

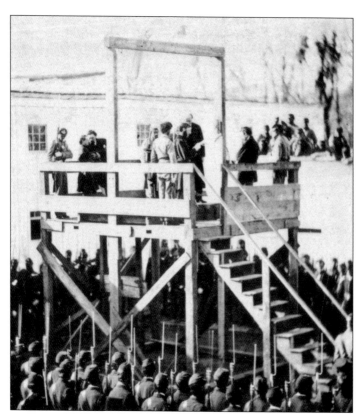

Major Russell is shown reading the death warrant for the Lincoln conspirators, one of whom was a graduate of Georgetown University. Photograph by Alexander Gardner.

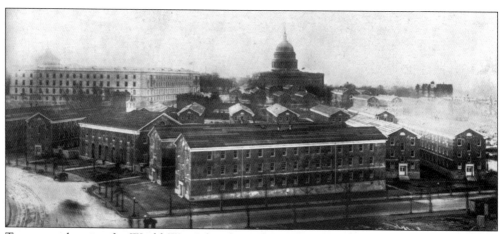

Temporary housing for World War I female workers who poured into Washington was built hastily on the east side of Union Station. Female defense worked bunked in these dormitories when Washington was ill-prepared for such an influx of new workers.

Although government employment declined in the 1920s, these dormitories survived until 1931, when they were torn down to expand the Union Station Plaza. As seen here, they were offered for sale in December 1929 by Thomas J. Fisher.

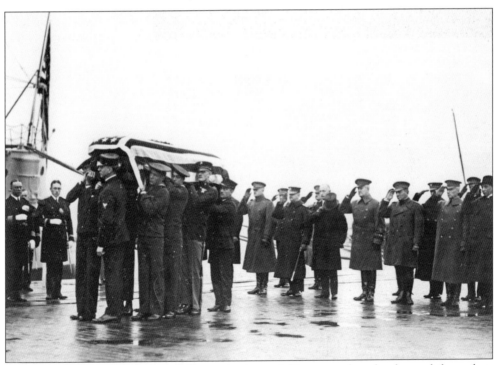

America's highest dignitaries of State, Army, and Navy stand and salute while caskets containing bodies of World War I soldiers are loaded at the Navy Yard to begin a slow procession to the United States Capitol Building.

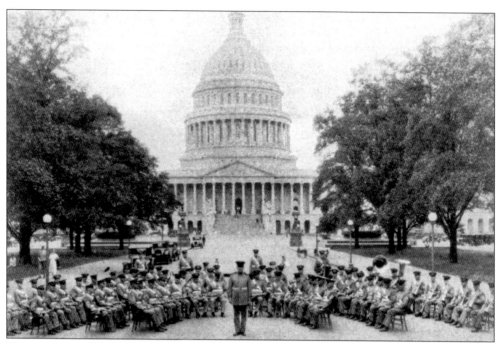

The youngest of the government's musical organizations at the time this image was taken in 1925 was the United States Army band, which was created at the end of World War I by the suggestion of General Pershing because he had lamented the lack of music during his command of forces in Europe. The band began their career by giving free concerts at Fort Hunt and the public parks of Washington. When they were not posing for photographs like this in the middle of East Capitol Street, the band was playing at such prestigious events as the country's sesquicentennial in Philadelphia in 1926.

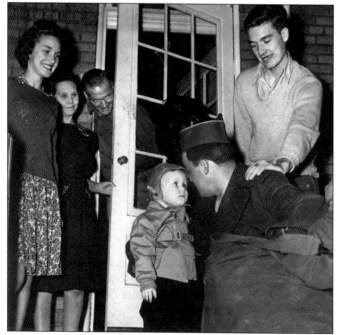

Cpl. Robert Russell returns to his home on Fifteenth Street NE in Capitol Hill after his separation from the U.S. Army on December 26, 1945. Greeting him are his sister, parents, brother, and young son.

Three

Churches, Hospitals, and Commercial Institutions

While the majority of Capitol Hill's residential development did not occur until the mid-to-late 1800s, places of worship were established much earlier.

Christ Church Episcopal Church at 620 G Street SE held its first service on August 9, 1807, and Presidents Madison, Jefferson, and John Quincy Adams all attended services there. Christ Church also established Congressional Cemetery in 1807 for the burial of senators, representatives, and executive officers; it was recognized by Congress in 1816 as the "semi-official" Congressional Cemetery.

St. Mark's Episcopal Church began services in the Sewell-Belmont House before beginning construction of its new location at Third and A Streets SE in 1888. The new church was completed in 1894 and featured a Louis Comfort Tiffany window in the Baptistery. Famous church-goers at St. Mark's included President Lyndon Johnson.

Capitol Hill also has been the home to many of the area's earliest health care facilities, including Providence Hospital, which erected its first building in 1872 at Second and D Streets SE. Providence Hospital was chartered by Congress to help the military during the Civil War. The original building was later replaced by a Spanish Mission–style building. Providence Hospital moved to 1150 Varnum Street NE before the buildings that comprised the hospital were condemned and demolished in 1965. Eastern Dispensary, Casualty Hospital's clinic at 217 Delaware Avenue NE, also called Capitol Hill home and treated those patients who could not afford health care.

Early commercial development included varied retail operations, and the neighborhood also was heavily dotted with hotels and apartments. Henry Brock's Congressional Hotel at New Jersey and Independence Avenues SE and the Varnum Hotel at New Jersey Avenue and C Street SE—once the home to Thomas Jefferson when the building was a boarding house—are two such examples. The Varnum Hotel was demolished to make way for the House of Representatives office building. The Capitol Park Hotel at Union Station Plaza was a popular hotel until it was taken over by the Federal Works Agency and converted to a serviceman's center, then remodeled for an officers' lounge for World War II.

Apartments also populated the area, including the Congressional Apartments located at East Capital and First Streets NE. Designed by Arthur B. Heaton, the Congressional Apartments were so named in efforts to attract Congressional members as residents.

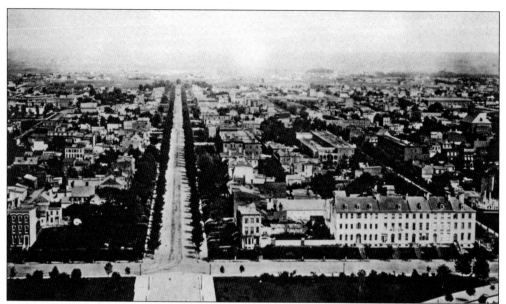

Capitol Hill is photographed from the Capitol Dome, c. 1880. First Street is in the foreground, while East Capitol Street runs to the Anacostia River in the distance. Also pictured is the Eastern Market and Carroll Row, now the site of the Library of Congress. The increasingly diverse population saw the emergence of places of worship and corner stores to address the needs of a dense population base.

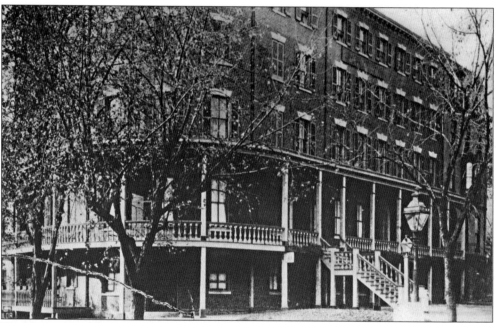

The Varnum Hotel at New Jersey Avenue and C Street SE is seen c. 1895; it was originally built as row homes by Thomas Law, who lived there in 1796 with his wife, the granddaughter of Martha Washington. Thomas Jefferson also lived here when he was vice-president; the building was then a boarding house. It then became the Varnum Hotel until it was demolished to make way for the House of Representatives office building.

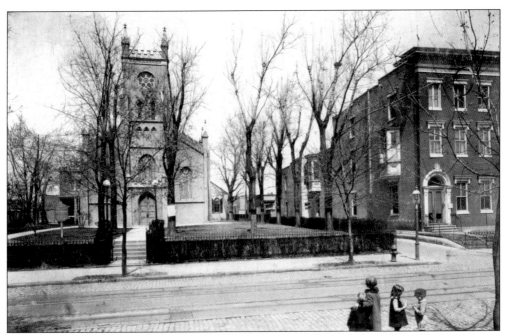

Christ Church Episcopal at 620 G Street, near Seventh Street SE, held its first service on August 9, 1807. According to tradition, Presidents Madison, Jefferson, and John Quincy Adams all attended services here.

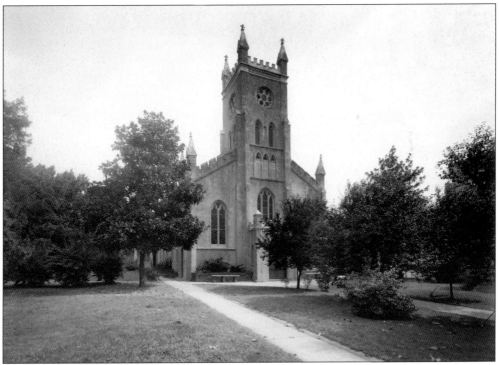

The narthex and the bell tower were added to Christ Church in 1849 and stucco was applied to the building in 1877. This vestry established Congressional Cemetery in 1807.

At the corner of Fourth and F Streets NE was a brewery that produced Juenemann's Lager Beer. Several stables and fuel sheds faced the 500 block of Fifth Street and the remainder of the site consisted of storage sheds and myriad outbuildings. The complex was owned by George Juenemann, and a large "manager's residence" was constructed at the corner of Fifth and E Streets with a large corner turret.

Juenemann's was renamed Washington Brewery by 1903, when most of the 500 block of Fifth Street remained void of development. The brewery complex was replaced in the 1920s by the Stuart Junior High School for white students.

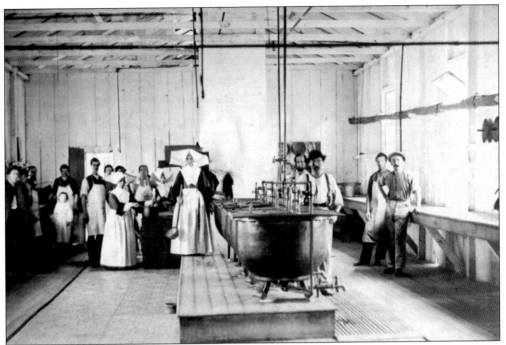

The Special Diet Kitchen of the Lincoln General Hospital, which later became Providence Hospital, at Thirteenth Street and South Carolina Avenue SE was headed by Sister Beatrice Duffy. She later became known as one of the institution's most revered administrators.

This frame building was the nurses' quarters for the Daughters of Charity during the Civil War. It was located on the grounds of Lincoln General Hospital.

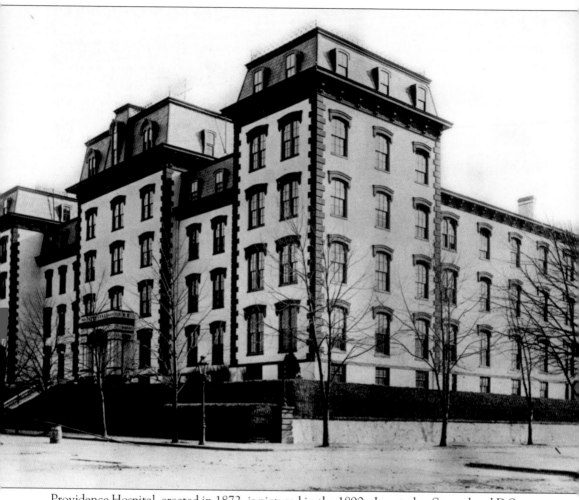

Providence Hospital, erected in 1872, is pictured in the 1890s. Located at Second and D Streets SE, Providence Hospital was chartered by Congress to help the military during the Civil War. After Providence moved to 1150 Varnum Street NE, this building housed the Commerce Department until it was torn down in 1964.

This is a list of the first patients at Providence Hospital in 1861.

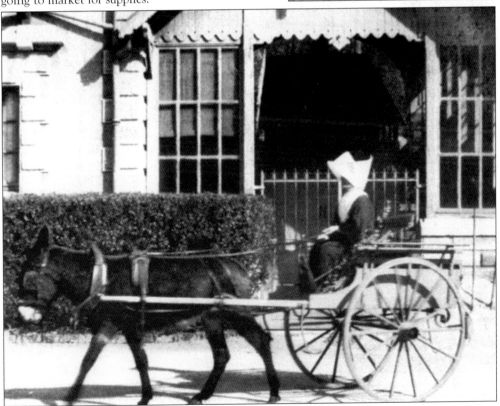

An 1870s image shows a Providence Hospital nun going to market for supplies.

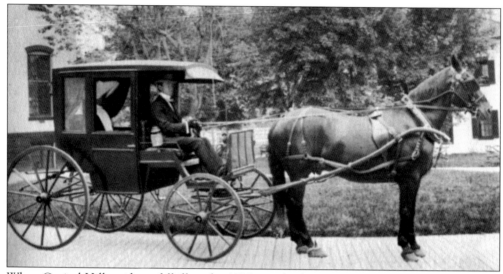

When Capitol Hill residents fell ill in the 1890s, medical assistance came via horse and buggy.

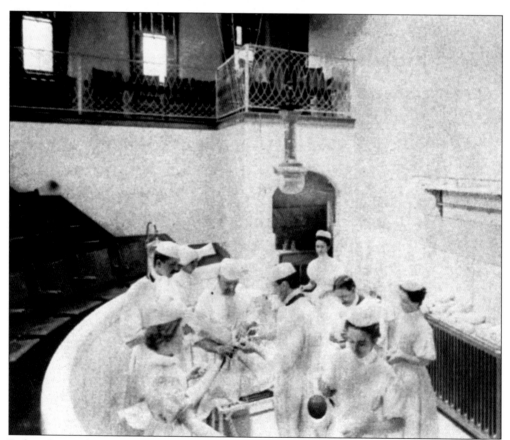

Before the emphasis on sterilization in the operating room, observers could come and go during a surgery, like this one in the Providence Hospital Amphitheater in 1895. Notice Dr. James Kerr operates with no gloves or a facemask.

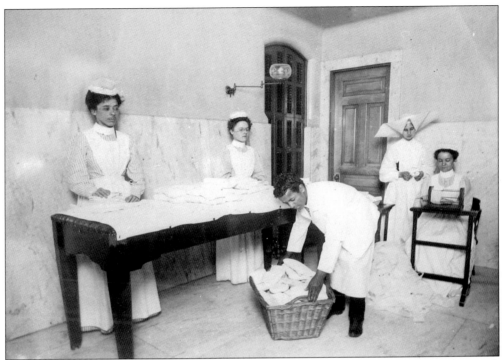

Part of the nurses' duties of the day was to roll bandages. In this case, nurses do so in a stark room in Providence Hospital lit by gas lighting fixtures.

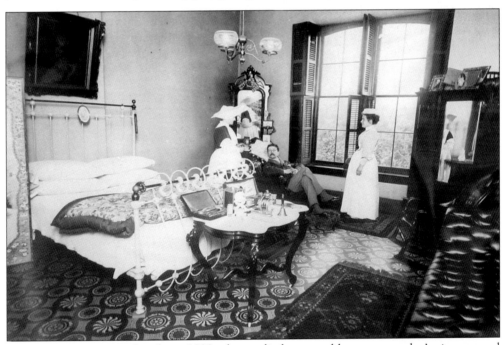

A private room in the late 1800s bares little resemblance to today's impersonal accommodations in hospital rooms. Long-term patients brought their personal effects, such as photographs, seen in this image.

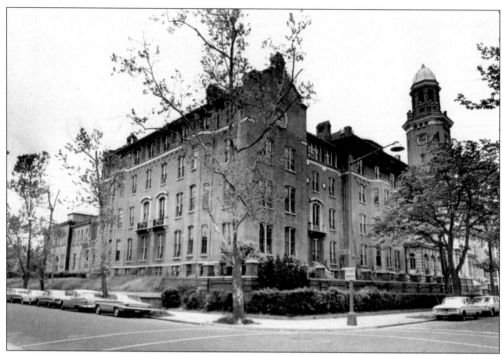

The original 1872 building was remodeled into this Spanish Mission–style building, complete with a monumental tower.

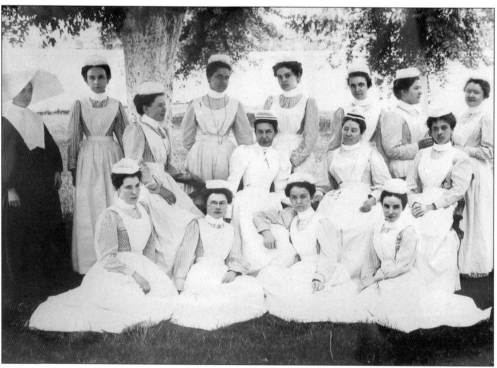

Early 1900s nursing school students at Providence Hospital attend patients in corseted dresses.

54

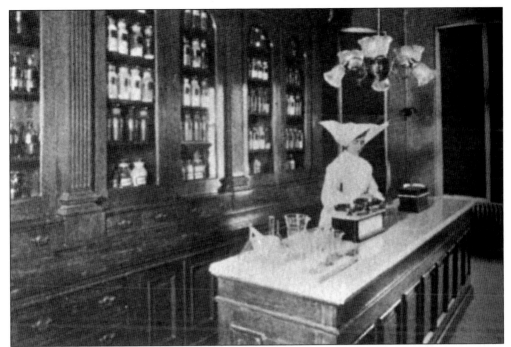

Providence Hospital's pharmacy is pictured c. 1904, displays a combination, state-of-the-art gas and electric chandelier, which was only utilized for a few years until electric lighting became more reliable.

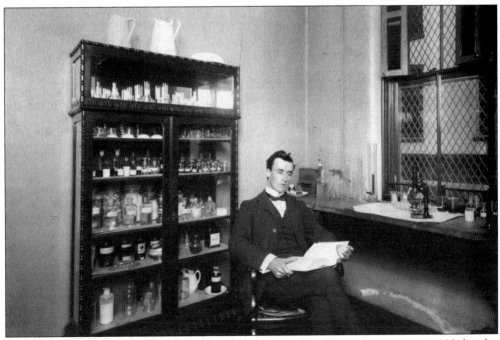

Physician Ralph A. Hamilton M.D. was a pathologist at Providence from 1910 to 1922; he also served as professor of pathology at Georgetown University. Dr. Hamilton is seen here with a microscope and the few chemical reagents of the time.

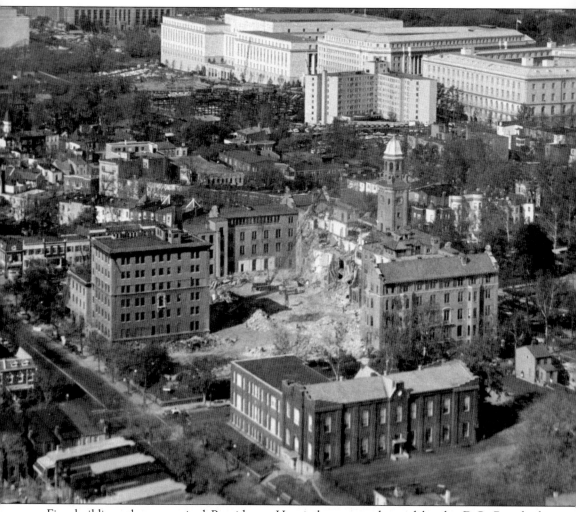

Five buildings that comprised Providence Hospital were condemned by the D.C. Board of Condemnation in May 1965 and were demolished in November 1965.

Eastern Dispensary, Casualty Hospital's clinic at 217 Delaware Avenue NE, is pictured c. 1900. The clinic treated those patients who could not afford health care. The building once stood on the site where the Senate office building now stands.

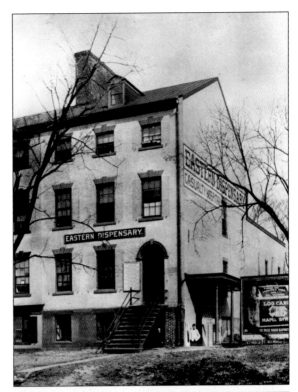

This former residence served as the Casualty Hospital and its clinic, Eastern Dispensary, at 708 Massachusetts Avenue NE.

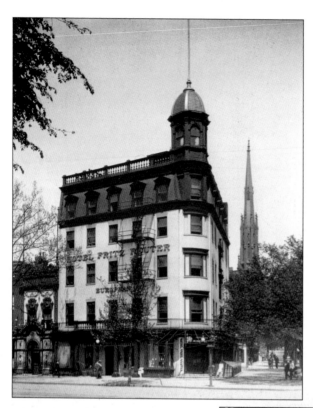

The Fritz Reuters Hotel at Four-and-a-half Street and Pennsylvania Avenue SE advertised itself as an "European Hotel."

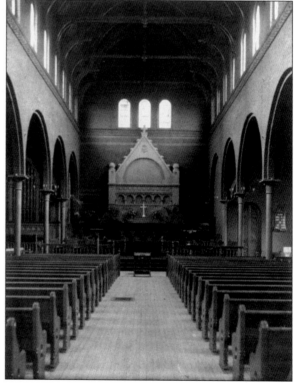

St. Mark's Episcopal Church began services in the Sewell-Belmont House before beginning construction of the sanctuary in 1888 at Third and A Streets SE. Designed by Baltimore architect T. Buckler Ghequier, the new church was completed in 1894 and featured a Louis Comfort Tiffany window in the Baptistery measuring 16 by 25 feet; it was a reproduction of Gustave Dore's *Christ Leaving the Praetorium*. The church has been enlarged many times; in 1894, it was enlarged to 120 feet with a tower and in 1926 it was enlarged to include a large parish hall. Famous church-goers at St. Mark's included President Lyndon Johnson.

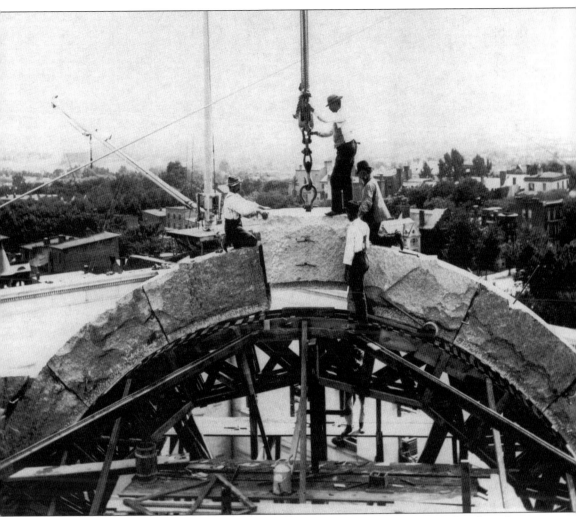

Highlighting the proximity of government buildings to the Capitol Hill neighborhood, workers set the arch of the new Library of Congress with Capitol Hill in the background on June 28, 1892.

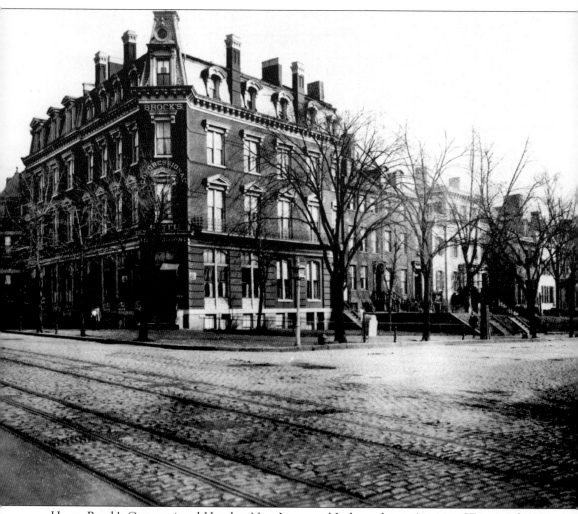

Henry Brock's Congressional Hotel at New Jersey and Independence Avenues SE is seen here. The site is now the Cannon House office building near the Capitol Grounds.

Dr. Augustus C. Taylor's Drugstore at Second Street and Maryland Avenue NE was a popular ice cream parlor and soda fountain when this photograph was taken in 1906. The building still stands today; it is located behind the Supreme Court.

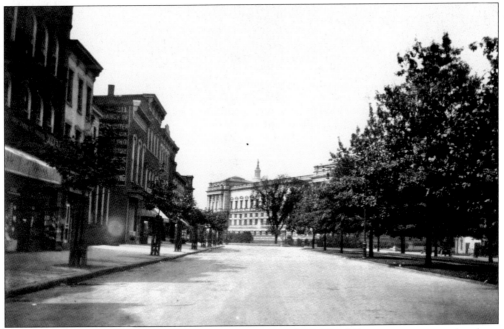

This view looks west on Pennsylvania Avenue in 1912 from Third Street, approximately where Starbucks is today. At the time, trolley tracks ran between the mature trees seen at right. Also pictured is the Library of Congress.

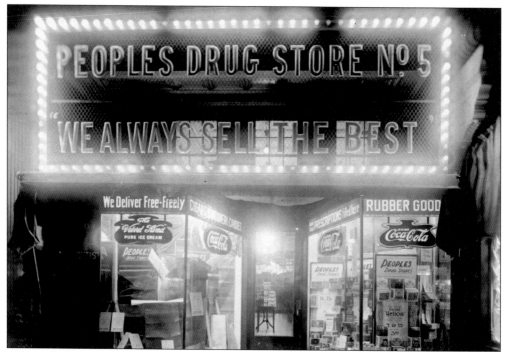

A brightly lit sign for Peoples Drug Store Number 5 at Eighth and H Streets NE made it easy for Capitol Hill residents to find a drug store day or night.

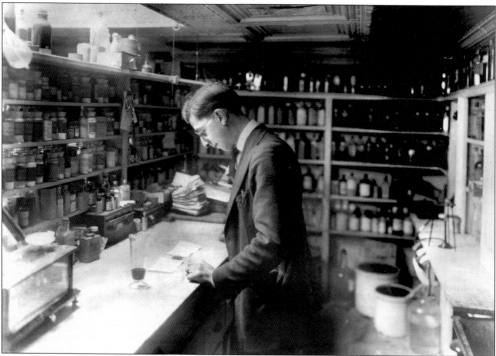

A pharmacist at People's Drug Store Number 5 is seen dispensing medicine from the ample shelves full of pharmacy bottles in the early 1900s.

Located at East Capital Street and First Street NE and designed by Arthur B. Heaton, the Congressional Apartments were so named in efforts to attract Congressional members as residents.

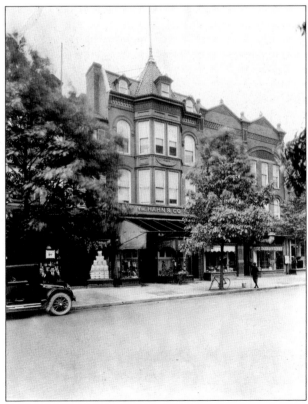

William Hahn & Company shoe store at 233 Pennsylvania Avenue SE is located next door to a coffeehouse, highlighted by the white bags of coffee beans stacked in the window, c. 1920. Incidentally, a Starbucks coffeehouse resides today in this former coffeehouse location.

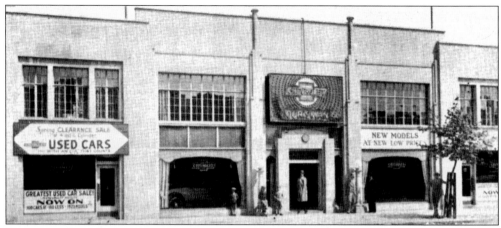

Ourisman Chevrolet got its start in 1920 at quite modest quarters at 625 H Street NE; following a successful start with the motto "Succeed by Satisfying" in 1925, Benjamin Ourisman erected a new sales showroom at 610 H Street NE. Its service department was open 24 hours a day. Just three years later, the company opened its first satellite office in Anacostia.

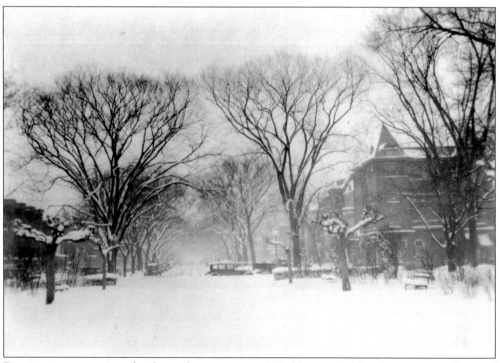

Despite its reputation for long, hot summers, Washington, D.C. does get its share of snowstorms, as photographed in a Capitol Hill snowstorm on East Capitol Street looking west from Twenty-First Street on January 30, 1930.

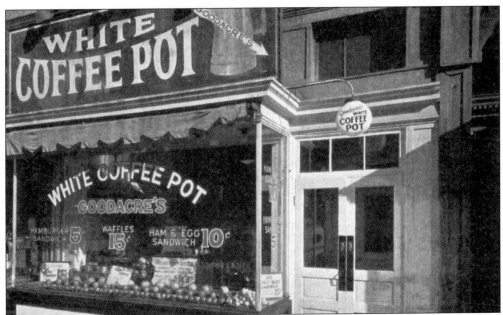

The White Coffee Pot restaurant chain was once a very familiar site in northwest, northeast, and southeast Washington, as this typical storefront was common to nearly all of the 11 locations. The business was started in 1890 by George L. Goodacre, who had learned that the average man required "good food, moderate prices, quick service, and clean surroundings," according to a 1930 advertisement. After discovering the difficulty of obtaining a steady supply of fresh eggs and dairy products that year, Goodacre purchased a farm just east of Silver Spring, Maryland.

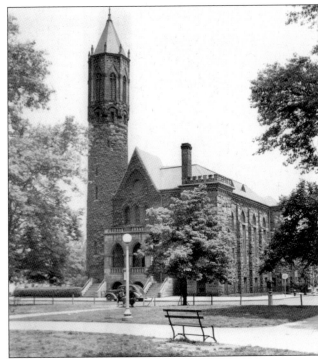

The Presbyterian Eastern church at Sixth Street and Maryland Avenue NE began in 1871, when a local group established a young men's prayer group in the private home of W.D. Hughes on H Street between Tenth and Eleventh Streets. They later met in the south wing of the Capitol Building while a chapel was being built, before merging with several Presbyterian congregations in the 1950s. This image appeared in the *Washington Star* on May 30, 1942.

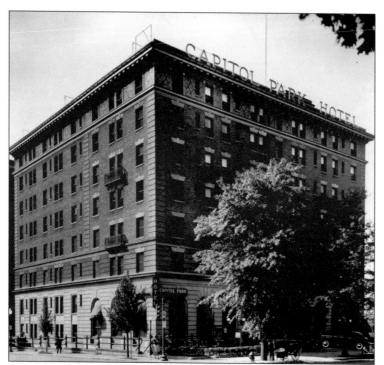

The Capitol Park Hotel at Union Station Plaza was taken over by the Federal Works Agency and converted to a serviceman's center, then remodeled as an officer's lounge for World War II. As noted by the sign, all guests had to vacate by August 31, 1943.

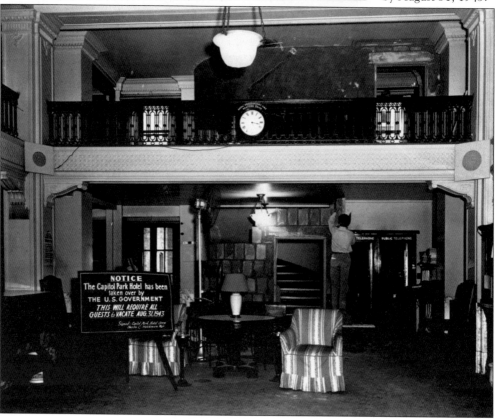

Four
COMMUNITY LIFE

Few neighborhoods in Washington, D.C., have seen the amazing transformation in landscape as Capitol Hill. The neighborhood's residential areas have been home to modest homes, devastating slum alleys, and now elite homes exceeding $1 million. Meanwhile, some of the earlier developments for the neighborhood were ambitious but unsuccessful, including one by speculative builder Capt. Alfred Grant to develop an area into a lavish and desired residential neighborhood in 1871, when he constructed a row of 16 mansions along A Street and 14 mansions on East Capitol Street. They were designed to sell for an impressive $75,000 each; however, the project failed, and they were eventually demolished and replaced by the Folger Shakespeare Library.

Capitol Hill has been home to many important individuals, including President Millard Fillmore; Italian immigrant Constantino Brumidi, whose frescoes adorn the rotunda and many rooms inside the Capitol Building; and Frederick Douglass. These individuals, as well as future Capitol Hill residents, have been supported by an array of community services.

Eastern Market, located at Seventh and C Streets SE and built in 1873, was part of a city-wide public market system to provide residents with an array of goods and services. Unlike many of its counterparts, Eastern Market survived the supermarket surge and remains open even today. Also noteworthy were Naval Lodge Number Four, the many fire stations that were built to service the community, and the Methodist Building at 100 Maryland Avenue NE, which housed the Methodist Board of Temperance, Prohibition, and Public Morals.

The early 1900s saw an unusual socioeconomic situation; Washington's alleys created a housing structure unlike any other city. In most cities where large lots contained a front and rear house, the two homes were similar in character and appearance; however, near the United States Capitol, rear homes faced winding roadways and were greatly inferior in condition and amenities.

By the late 1950s, the middle class population of Capitol Hill moved away to the suburbs, and following the riots that devastated many parts of Washington, D.C., including Capitol Hill, many homes were abandoned and replaced with commercial buildings.

The 1960s and 1970s saw a decline in the quality of life in Capitol Hill until an upward surge began in the 1980s and transformed the neighborhood into an elite one populated with high-end homes and high-caliber restaurants and services.

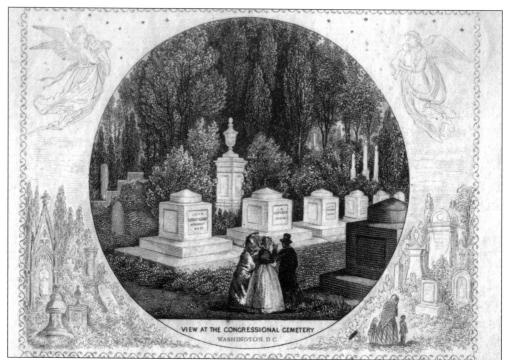

This 1850 engraving is of the Congressional Cemetery, which is administered by Christ Church and is bounded by the Anacostia River, Seventeenth Street, Potomac Avenue, and E Street SE.

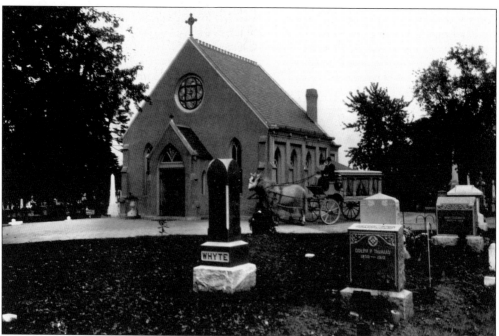

Many notable historical members are buried in Congressional Cemetery, including Elbridge Gerry, second vice-president of the United States and a signer of the Declaration of Independence, and many members of Congress.

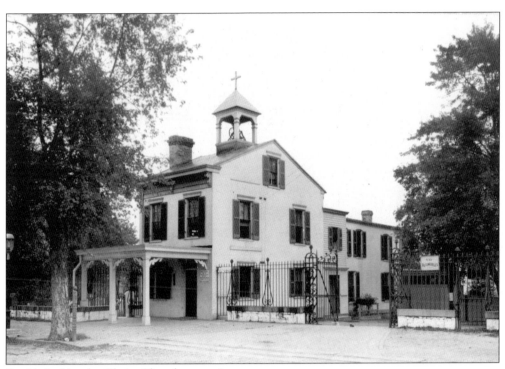

Established by the Christ Church vestry in 1807 for the burial of senators, representatives, and executive officers, Congressional Cemetery, also known as the Washington Parish Burial Ground, was recognized by Congress in 1816 as the "semi-official" Congressional Cemetery and received financial assistance in order to reserve a section of the burial grounds for government officials.

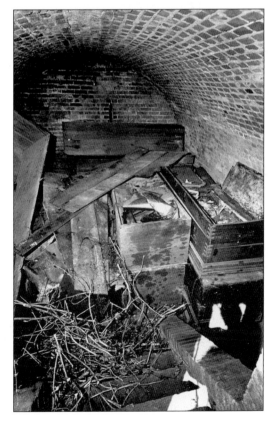

Rifled caskets in a Congressional Cemetery Mausoleum show the age of the burial grounds, established in 1807.

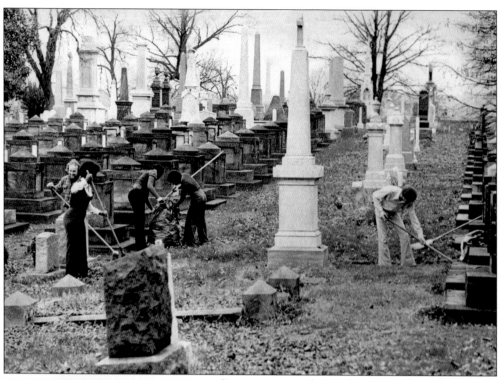

Community members volunteer to clean the grounds at Congressional Cemetery, which had shown signs of decline.

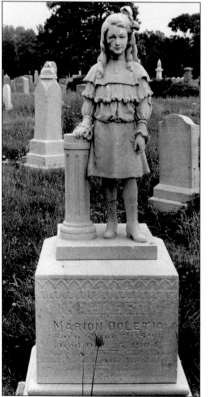

Photographed at Congressional Cemetery is the headstone of Marion O'oletia, Washington's first traffic victim at the tender age of 10. Photo by John Bowden.

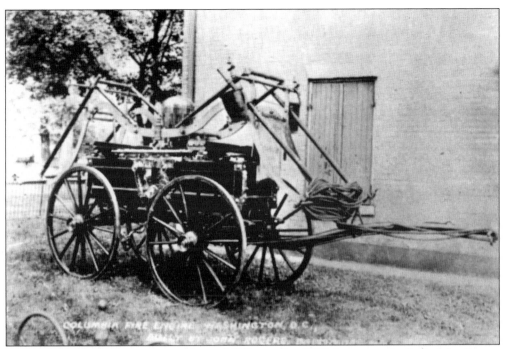

One of the earliest fire engines in Capitol Hill was this 1850 fire engine built by John Rogers of Baltimore for the Columbia Engine Company of Capitol Hill.

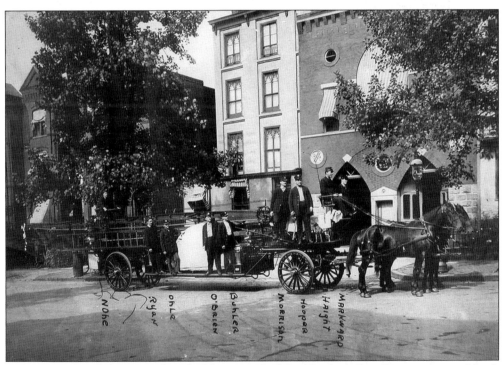

Early Capitol Hill firemen, identified here, worked for Truck A Fire Department on North Capitol Street and C Street NE, which was located near the current site of Union Station.

Capitol Hill has been home to many important individuals, including President Millard Fillmore, whose home at 224 Third Street SE is pictured above, to the left. Fillmore was inaugurated in 1850 and served one term. The home on the right—226 Third Street SE—was called the Indian House and was one of the most prominent hostelries close to the Capitol. Photo by Hugh Miller of the *Washington Post*, 1920.

Italian immigrant Constantino Brumidi (1805–1880), whose frescoes adorn the rotunda and many rooms inside the Capitol Building, lived on Delaware Avenue between B and C Streets when he first came to Washington in 1852. Marital problems and relationships with a variety of women, however, had him living in various places during his tenure at the Capitol. Brumidi died on February 19, 1880, a day after losing consciousness while painting in the Capitol Dome.

72

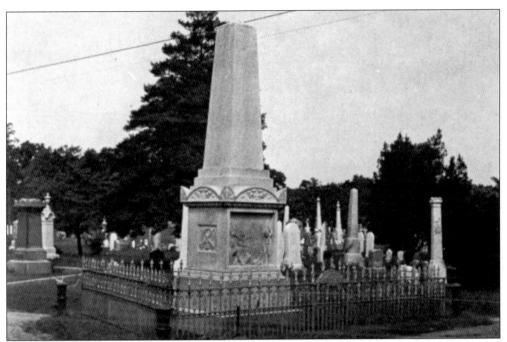

Pictured at Glenwood Cemetery is the gravesite of Benjamin C. Grenup of the Columbia Engine Company; he was the first firefighter of record to be killed in the line of duty in Washington, D.C. The iron fence was part of the original fence around the Columbia Engine Company of Capitol Hill and his gravesite includes life-size fire hydrant replicas.

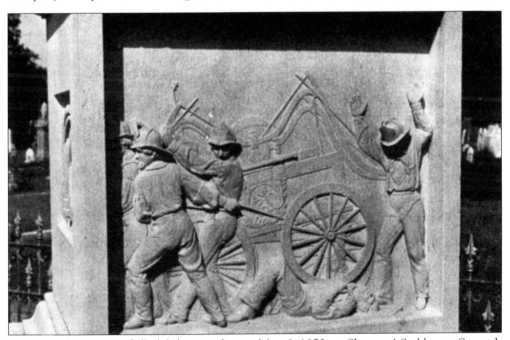

Benjamin Grenup was killed fighting a fire on May 6, 1853, at Shreeves' Stables on Seventh Street. His epitaph reads, "A truer nobler trustier heart more loving or more loyal never beat within a human breast."

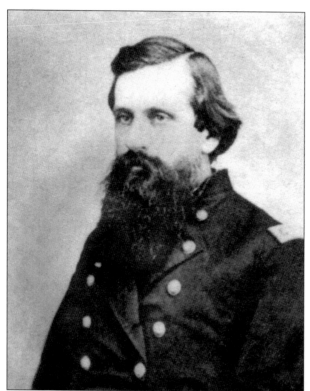

Gen. John Eaton, pictured here in 1863, lived at 712 East Capitol Street NE in a substantial wood frame house that was later razed to build a mansion for Antonio Malnati, who owned a stonecutting company near the current site of Union Station. Originally an educator, Eaton joined the military and was appointed by Ulysses S. Grant to run the "contraband" camps, caring for and organizing the large numbers of African-American men and women who escaped slavery behind Union lines. Eaton was rewarded with a colonel's commission in the 63rd United States Colored Infantry in 1863 and was brevetted brigadier general in 1865 (only whites at that time could be commissioned officers). The John Eaton public school in Cleveland Park is named in his honor.

Eastern Market, located at Seventh and C Streets SE, was built in 1873 and designed by Adolph Cluss, a prominent architect who also designed the Franklin and Sumner Schools, the Smithsonian Arts and Industries Building, and many other post–Civil War buildings.

At the end of the Civil War, the city was under pressure to erase its image as a sleepy, Southern town or have the federal government removed. Therefore, Eastern Market was used to reshape the city's image and became the first city-owned market to be built under the public works program of the 1870s.

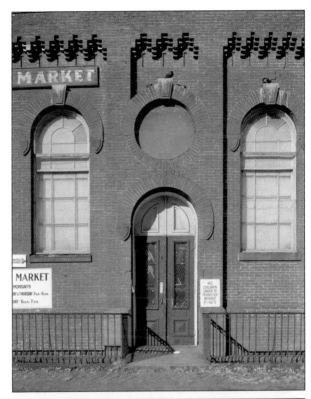

Part of a city-wide public market system, Eastern Market was built to provide residents with an array of goods and services and symbolized the much-needed urbanization of Washington, D.C. Unlike many of its counterparts, Eastern Market survived the supermarket surge and remains open even today.

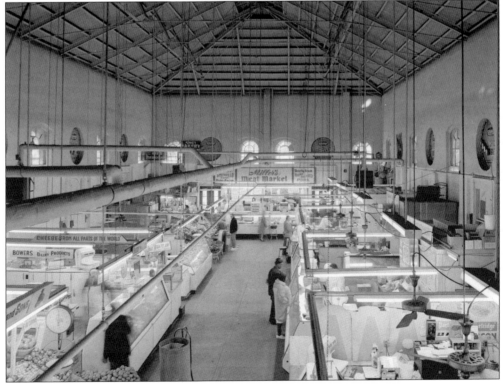

The building at 500 East Capitol Street, seen here as Mary's Blue Room in 1983, was constructed in the 1870s but was razed in 1972. In 1930, the house was advertised in the *Book of Washington* as the East Capitol Dining Room, "catering to tourists and visitors and maintaining a clientele of the nation's great and near great from the halls of Congress." It was then run by Lora Carleton, who served home-cooked meals "so much talked about but so seldom found."

These houses at the corner of Second and D Streets NE, likely built in the 1870s, show the intersection without the traffic found there today. One could leisurely stroll right down the center of the street.

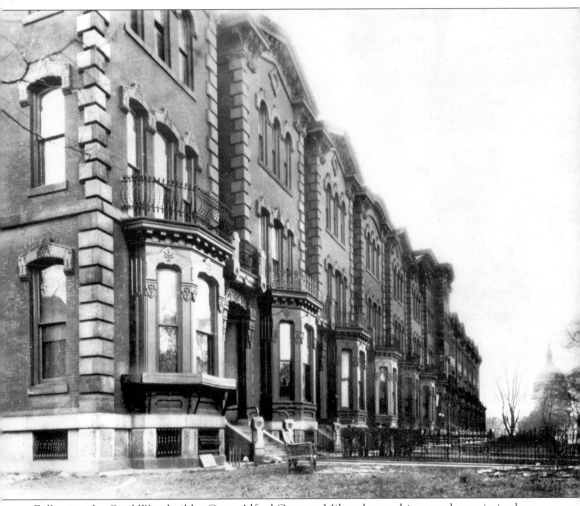

Following the Civil War, builder Capt. Alfred Grant, a Milwaukee architect and captain in the Union Army, attempted to develop an area of Capitol Hill into a lavish and highly desirable residential neighborhood. From 1870 to 1871, Grant speculatively constructed a row of 16 mansions along A Street and 14 mansions on East Capitol Street. The homes on East Capitol, between Second and Third Streets SE, (pictured here) were designed to sell for an outrageous $75,000 each and were leveraged, as was much of the speculative development at that time. The market did not support the overly luxurious homes and the development went bankrupt. About 50 years later, Henry Folger bought the entire row for $300,000, tore it down, and built Folger Shakespeare Library.

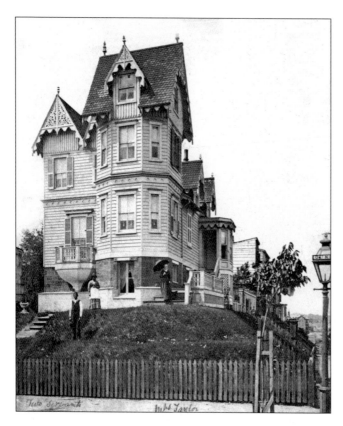

One of the many glamorous homes in Capitol Hill in the late 19th century was located at 238 D Street NE; it was the home of Thomas Taylor M.D. Mrs. Taylor is pictured with two of the home's servants.

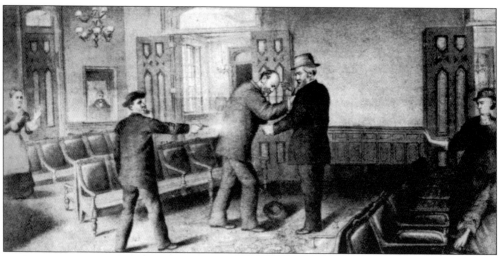

Charles J. Guiteau, a disgruntled job applicant, assassinated President James Garfield in the waiting room of the Baltimore & Potomac Railroad Depot in Washington on July 2, 1881. Garfield lived for 11 weeks after the shooting; during this time Alexander Graham Bell developed a metal-detector device in the hope of locating the assassin's bullet in Garfield's body. However, doctors failed to remove the metal bedsprings in Garfield's bed, which kept the device from pinpointing the bullet's location. Garfield died on September 20, 1881.

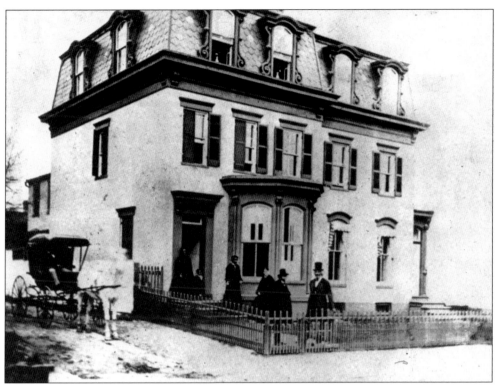

Frederick Douglass and his family are pictured in 1885 at their home at 316 A Street NE. An ex-slave, Douglass later became the editor of the weekly publication *New National Era*. The home now houses the Museum of African Arts.

Capitol Hill obtained an additional fire station when Engine Company Number Eight began operating on January 22, 1889, on North Carolina Avenue between Sixth and Seventh Streets SE.

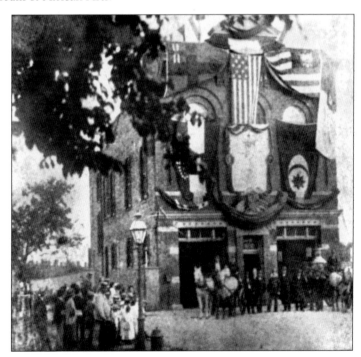

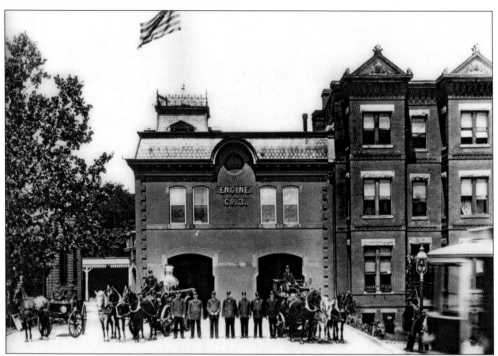

Fire Engine Company Number 3 is pictured c. 1890. It was located at C Street and Delaware Avenue NE.

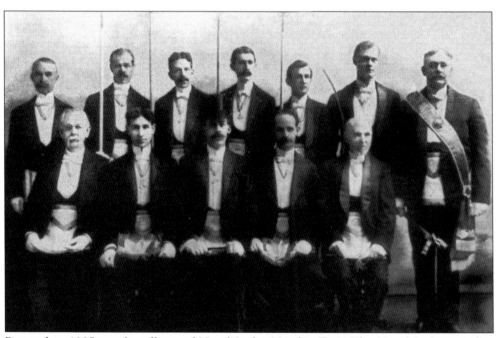

Pictured in 1905 are the officers of Naval Lodge Number Four. The Naval Lodge was first located in the Old Masonic Temple at Virginia Avenue and Fifth Street SE. The temple was built in 1821 as a two-story building and a third story was added in 1867. It was home of one of the oldest Masonic bodies in Washington, D.C., before it was demolished.

In 1884, a committee of Naval Lodge members began seeking property to construct a new building. At the time, property on the 400 block of Pennsylvania Avenue could be purchased for $1.25 per square foot. Unfortunately, movement to purchase land was shelved until 1891, when land had increased to $3 per square foot, and it was not until 1893 that the Lodge purchased the land at the corner of Fourth and Pennsylvania Avenue SE. The building was completed in early 1895 at a cost of $36,549.

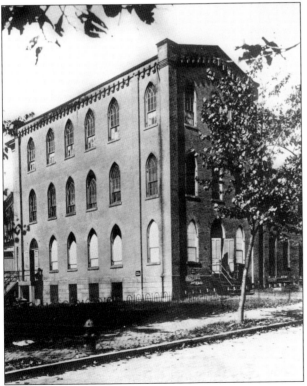

In order to pay for the new building, the Lodge had to sell their property at Fifth Street and Virginia Avenue SE to the Colored Masons of the District in 1893. Since the new building would not be completed until 1895, the Lodge had to find temporary accommodations to meet; hence, they met at Potomac Number Five Lodge in Georgetown from November 1893 to April 1895.

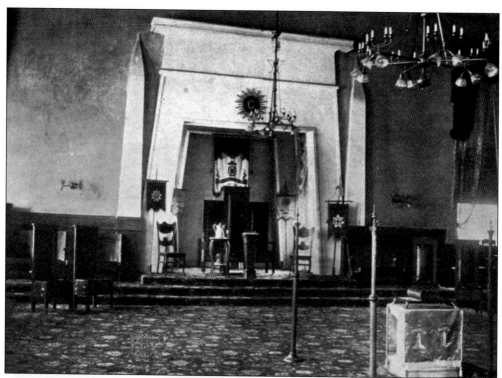

The building committee for the Lodge was able to furnish the new building with carpets and furniture for a mere $1,999, and the new lodge was occupied for the first time on May 2, 1895. Pictured is the Lodge Room, which was 48 feet wide, 52 feet long, and 27 feet high. The room housed the organ and choir and was accented with Egyptian motifs.

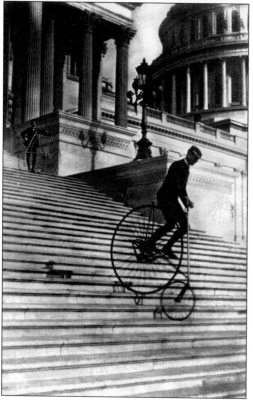

Entitled *A Perilous Ride*, this image shows a brave velocipede rider making his way down the United States Capitol steps.

Fire Engine Company Number Ten, located at 1341 Maryland Avenue NE, was built in 1894. The addition of another fire station signaled Capitol Hill's rapid growth.

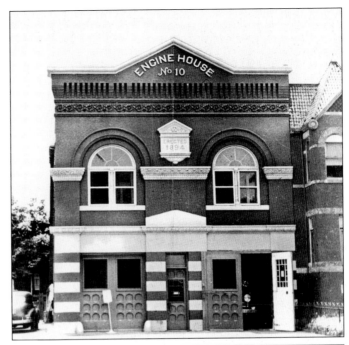

A line drawing of 119 Sixth Street NE shows one of many homes documented by the Historic American Building Survey, a component of the Works Progress Administration, a Depression-era program to employ the many unemployed architects, photographers, and historians. One of the goals of Historic American Building Survey was to document the buildings in danger of being razed in Capitol Hill, which would later become one of the largest historic districts in the city.

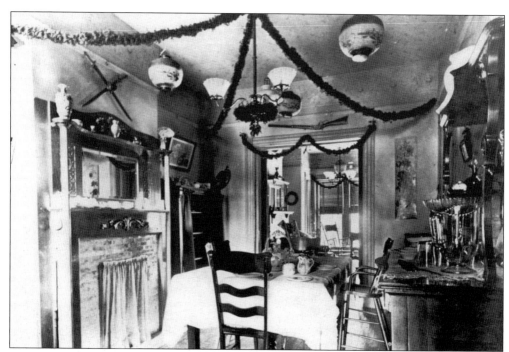

Pictured is the dining room of amateur photographer Henry Taft's home at 628 Ninth Street NE. The Taft family moved into the home in 1898 and decorated the room with Chinese lanterns and Christmas wreaths, which were popular at the time, as were fireplace mantels with mirrors.

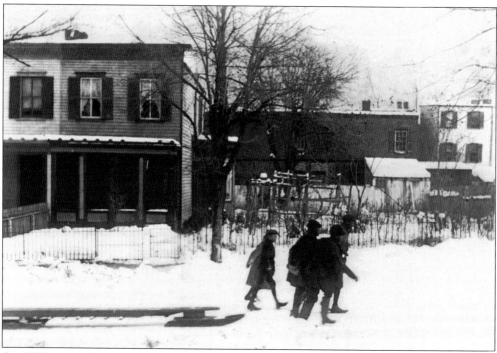

An 1899 image depicts a snowstorm in the 600 block of Ninth Street NE. The homes pictured are across the street from Taft's home and predate his home's construction.

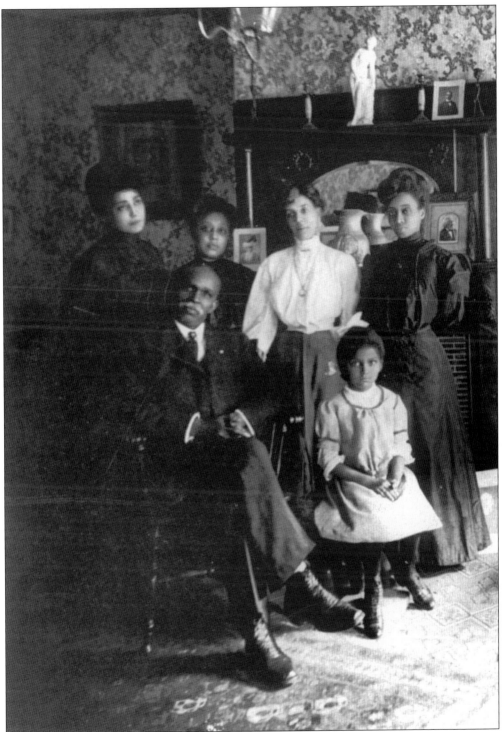

The Sprague family, descendants of Capitol Hill resident Frederick Douglass, is shown here in their formal parlor. Douglass's photo can be seen above his granddaughter, Roseabelle Sprague Jones, who is standing at the far right.

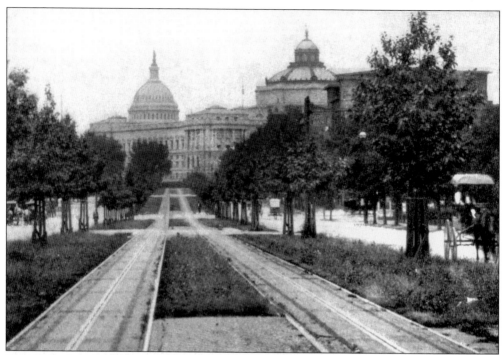

This 1901 photograph is titled *Unhappy effect of having the Library of Congress located across from the U.S. Capitol,* apparently in reference to a blocked view for Capitol Hill residents.

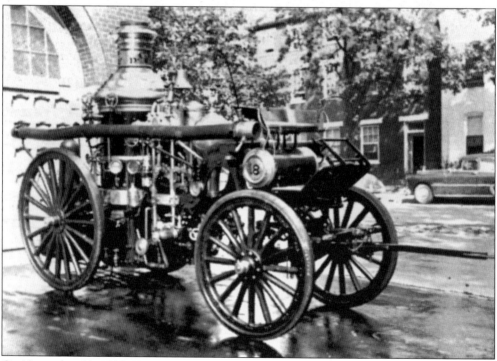

On November 18, 1905, Engine Company Number 18 was organized at 1001 Ninth Street SE to primarily address the needs of the nearby Navy Yard.

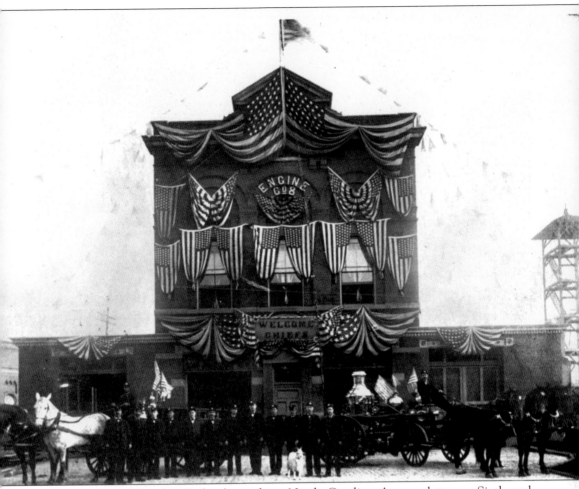

Engine Company Number Eight, located on North Carolina Avenue between Sixth and Seventh Streets SE, included a goat mascot pictured here in the forefront. The firemen team is seen as they welcome fire chiefs in 1907.

One of the many depressed, slum areas around the Capitol in 1908 was Purdy's Court located on First Street, which was then occupied by 70 Italian immigrants.

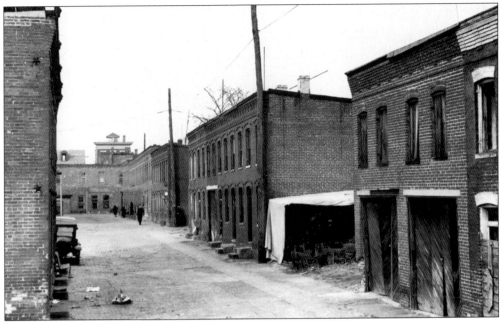

Washington's unique alleys created a housing situation unlike any other city. In most cities where large lots contained a front and rear house, the two homes were similar in character and appearance and typically the rear home's residents entered through the front home. Near the United States Capitol, however, rear homes faced winding roadways and were greatly inferior in condition and amenities.

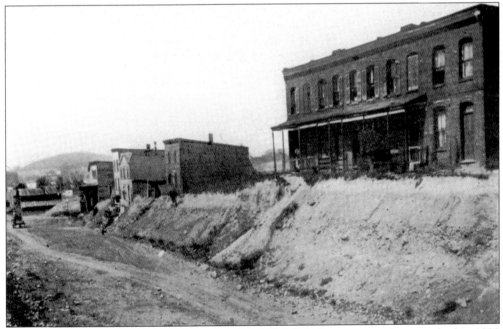

Houses on Eighteenth Street, between East Capitol and A Streets, were photographed in 1908 to depict the inhumane conditions in which residents were forced to use wooden box toilets that were rarely cleaned or serviced.

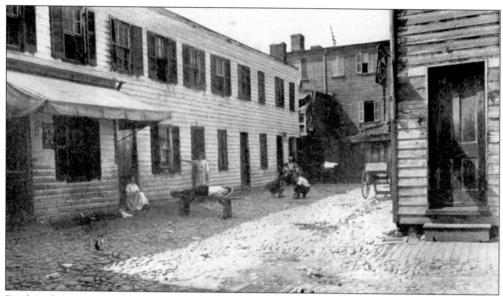

Purdy's Court at the foot of the Capitol Grounds was one of the many alley areas where residents lived in poor conditions in the shadow of the United States Capitol.

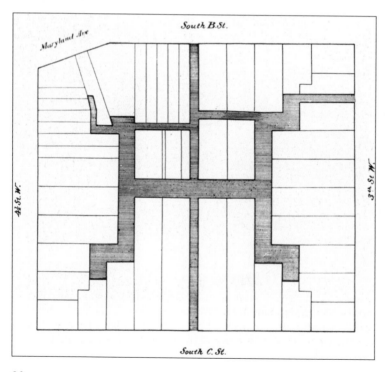

The darker areas of this map show the alley called "Willow Tree Alley," where 273 white and 228 black residents lived in this small area. Willow Tree Alley was considered one of the worst areas with its 501 crowded inhabitants.

Only two blocks from the Capitol, "Bassett's Alley" was an example of a "hidden alley" with an entrance only three feet wide. In one row of three homes, eight families lived in the 10 rooms available. Rentals for these rooms—some of which had only six-foot ceilings—were $2.50 for one room or $4.50 for two rooms. Many of the alley rooms were located below the surface of the yard causing them to flood with each rainfall.

The Alley Dwelling Authority identified many homes to be demolished, including 409 Eye Street SE, pictured here. Some homes were condemned, some were reformed for commercial purposes, and there was an attempt to work with existing structures to improve conditions by the opening of a minor street.

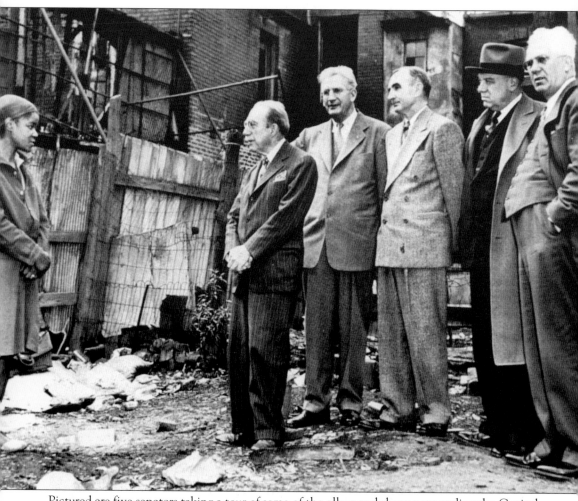

Pictured are five senators taking a tour of some of the alleys and slums surrounding the Capitol. In the late 1940s, the federal government undertook more serious efforts to condemn rundown buildings and replace them with redevelopment projects. Through the federal government's actions, local authorities were given more power. Dr. Scott Nearing, author of *Poverty and Riches*, studied the alley slum areas and noted, "In this rich land there are avenues of wealth, and the alleys of poverty lie side by side. With ease, comfort, and luxury in abundance, poverty lurks and snarls. What is poverty? Poverty is found wherever a family is living on an income that will not provide for physical health and social decency."

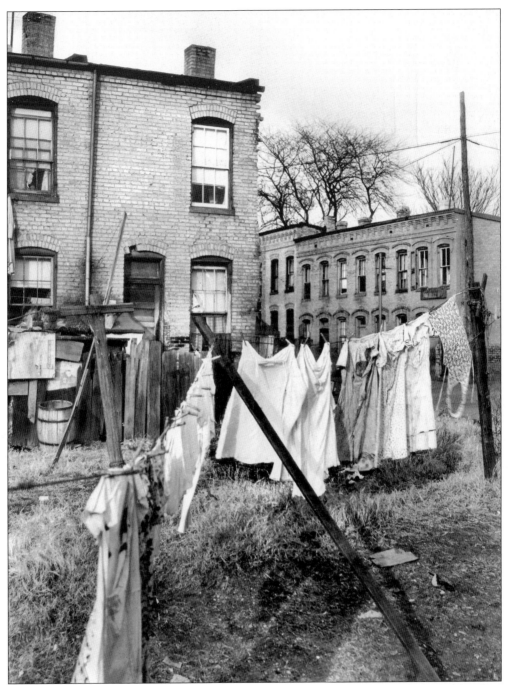

Many alley homes' rear yards were littered with washings that women in the household took in from more affluent neighbors. Many black men had difficulty finding work and were solely supported by the women of the household who had less problems finding household work.

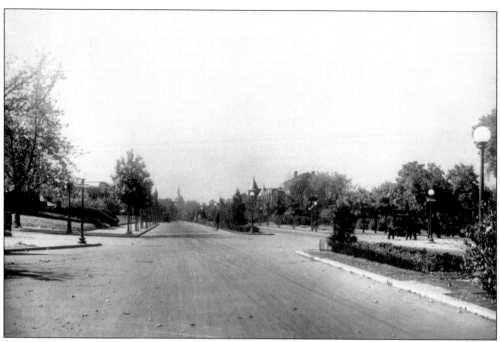

This is a view of Maryland Avenue NE at F and Twelfth Streets, looking toward the Capitol in the early 1900s, near the present site of the Roosevelt Apartment Building.

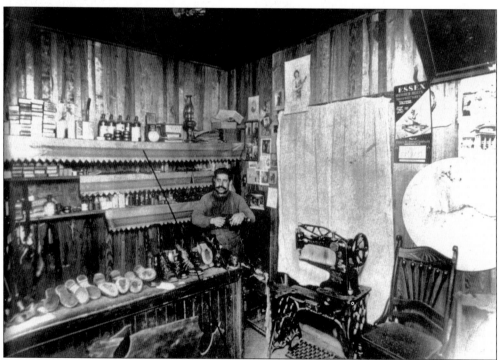

An influx of Italian immigrants helped accommodate the service industry's needs, including boot and shoe repair. Italian immigrant James Zagami is pictured in his Capitol Hill shop at 915 C Street SE, *c.* 1912.

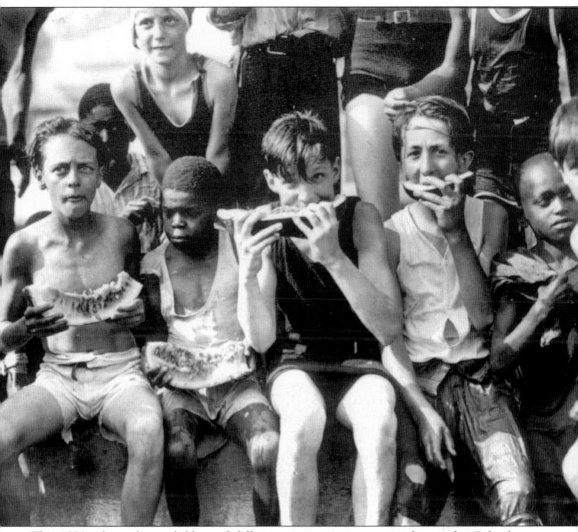

This 1920s photo shows children of different races enjoying watermelon at the Columbus Fountain located in front of Union Station.

The Methodist Building at 100 Maryland Avenue NE was designed by Walter F. Ballinger of Philadelphia. The 1917 plans for a six-story marble-façade classical structure were never carried out because of the government's restrictions for materials to be used to aid World War I efforts; therefore, the building was erected in 1923 and opened in 1924 as rental space with 15 apartments. It also housed the Methodist Board of Temperance, Prohibition, and Public Morals, established in Chicago in 1888. Although the 18th amendment mandating prohibition went into effect in 1920, the building was still erected. The board also campaigned against dancing, motion pictures, boxing, tobacco, immigration, and the Roman Catholic Church.

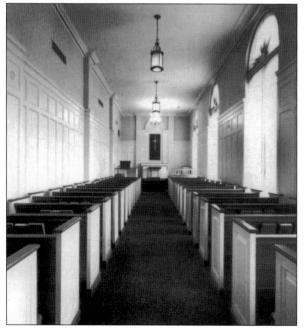

The Methodist Building was one of only two apartment buildings in Washington with private chapels. An annex was built in 1931 with an auto turntable to aid in parking in the tight garage. The design of the annex was the first building reviewed by the Commissioners of Fine Arts (CFA) under the terms of the Shipstead-Luce Act of 1930 that authorized the CFA to approve all designs close to government buildings. The church's original 72-foot annex design was rejected due to its proximity to the Supreme Court. Apartments in the original building were converted into offices from 1975 to 1985.

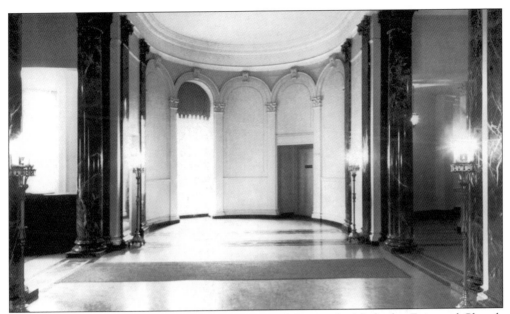

To support the Prohibition movement in the United States, the Methodist Episcopal Church (Northern Branch) purchased land in 1916 to obtain a physical presence on Capitol Hill to aid the Prohibition movement. The building housed church offices on the lower two floors and had rental apartments above it. They hoped the apartments would be rented by Congressmen to allow them to assert their influence on Congressional members. Many Congressional members lived there, including Albert Gore Sr., in the 1960s.

A corner building at New Jersey Avenue and E Street SE shows one of many pie-shaped lots in Capitol Hill due to L'Enfant's plan, which included a grid plan with diagonal streets that sometimes intersected to form triangle-shaped lots, c. 1924.

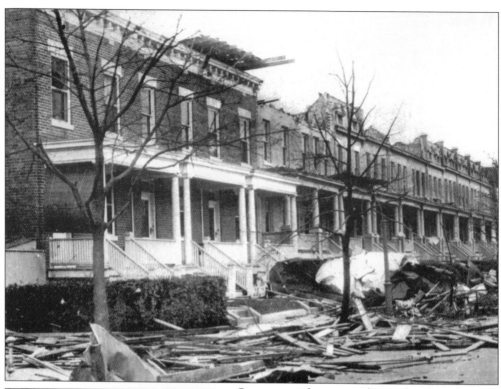

Storm-swept houses on the south side of A Street between Thirteenth and Fourteenth Streets are seen following a tornado that ripped through Capitol Hill on November 27, 1927.

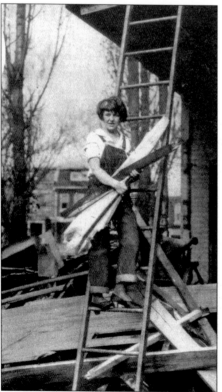

Miss Betty Wilson, in her high heels and overalls, does not leave all the labor of recovering from the 1927 Capitol Hill tornado to the men of the family.

This advertisement for the Norton Inn at 509 East Capitol Street appeared in the *1930 Book of Washington* and describes the inn as a place that "supplies an ideal service for the tourist, the sightseer, or with business on Capitol Hill." It was equipped with "modernly furnished and decorated rooms, cool in summer, warm in winter, hot and cold water, cribs for children on request, and other family conveniences, instantaneous hot water for shower baths, electric lights, telephone, and radio located in living room or lobby." It was then owned and operated by Mrs. May E. Norton.

Norton Inn

509 EAST CAPITOL STREET

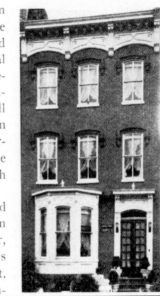

within
of the
e, hard
essional
Shake-
nd cen-
to all
Norton
eal ser-
ist, the
se with
l Hill.
hed and
cool in
winter,
r, cribs
request,
conven-

iences,
water
electric
and rad
room o
comfort
for a c
For the
sightsee
city gui
and a ge
rear of
be obtai
May E.
prietres
8977.

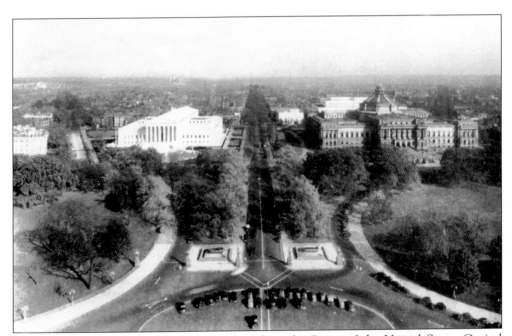

This image of East Capitol Street was taken from the Dome of the United States Capitol Building in 1935. Pictured on the left is the new Supreme Court building, and the Library of Congress is pictured on the right.

Located at 1252 Maryland Avenue NE and built in 1892, this home was owned by James E. and Gustavia Eubanks beginning in 1947. The Eubanks began the Washington Junior College of Music and Education and moved the class sessions to their new home. A 1949 newspaper article featured the couple, who maintained an impressive 12 pianos and one organ at the property, on which 200 students from kindergarten to college age were taught. (Photo courtesy of and copyright by Andrea C. Kelly.)

The Washington Junior College of Music and Education eventually offered a four-year course of study that involved classes in piano, violin, wind instruments, theory, harmony, voice, music history, reviewing, ear training, sight singing, choral rehearsal, and music appreciation. (Photo courtesy of and copyright by Andrea C. Kelly.)

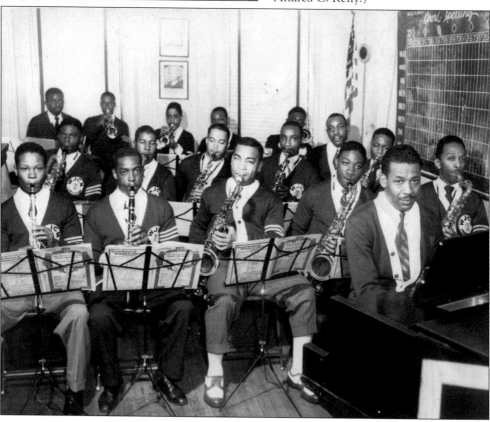

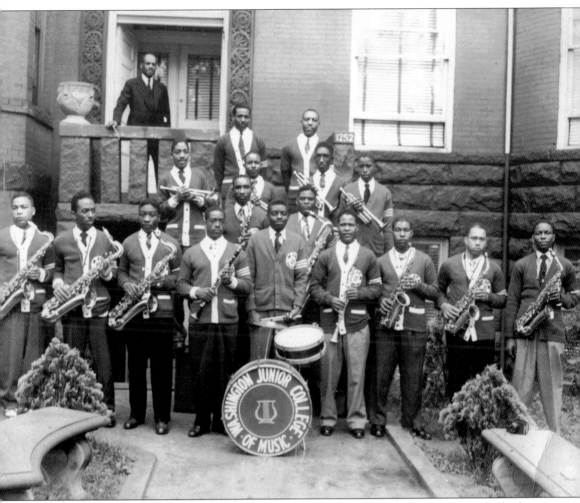

The Washington Junior College of Music offered classes at 1252 Maryland Avenue for both kindergarten-age children and mature musical students of collegiate age. Despite their age or classroom, however, all students had to adhere to strict rules posted by James Eubanks throughout the school. He stated that students disobeying the rules would be "dropped immediately." The home is still owned by Eubanks family descendants. (Photo courtesy of and copyright by Andrea C. Kelly.)

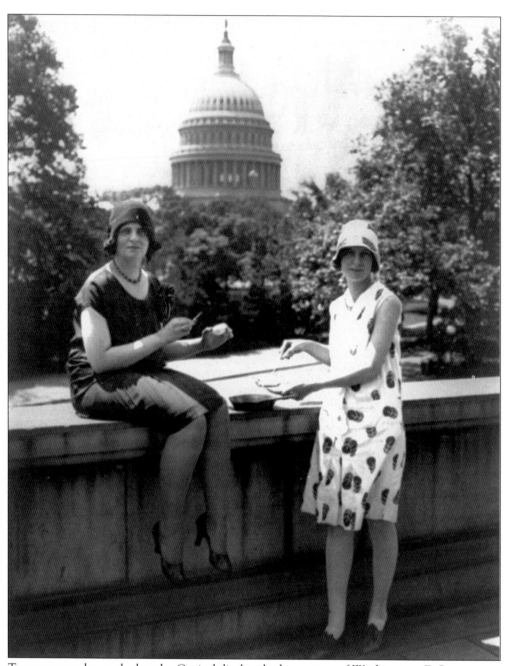

Two women who worked at the Capitol display the hot nature of Washington, D.C., summers by frying an egg on a marble railing of the Capitol wall on June 14, 1929, a short distance from their workplace.

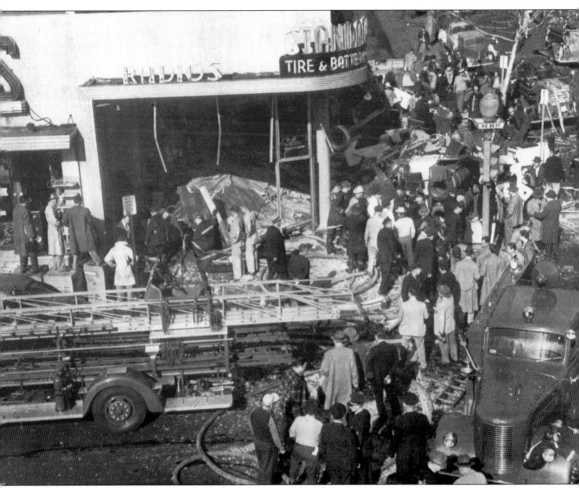

"Black Thursday," a day most notably marked by the crash at Union Station, was a challenge for firefighters all over the city. A seemingly routine fire at Standard Tire and Battery at Tenth and H Streets NE took an unexpected turn when a basement explosion hurled firefighters through plate glass windows. Firefighters in the basement at the time were saved by the rubber tires that served as buffers from the flames. Firefighters were thrown as far as 40 feet; 42 were hospitalized, but fortunately none were killed.

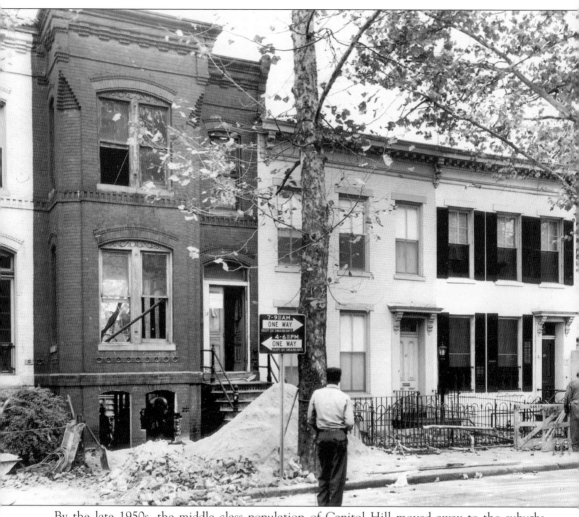

By the late 1950s, the middle class population of Capitol Hill moved away to the suburbs. Many of those who left were African Americans, who could now buy homes in neighborhoods that were unobtainable to them before the 1948 Supreme Court ruling that declared housing covenants unconstitutional. This picture of the 100 block of D Street SE shows the need for restoration.

When the Navy Yard ceased the manufacturing of weapons in 1962, many blue-collar families who worked there left Capitol Hill. In return, many low-income black families, as well as middle-to-upper class white families, moved into the neighborhood. Carroll Terrace SE between A Street and East Capitol Street is pictured c. 1960.

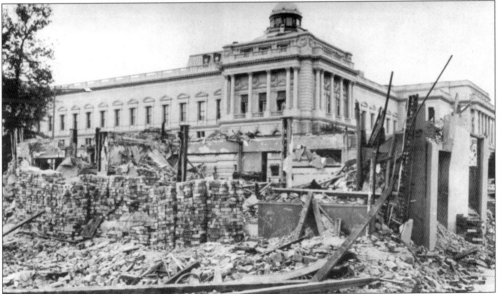

A two-block area south of the main Library of Congress building once held over 100 fine early 20th century buildings, along with a block known as Ptomaine Row. Home to burger joints and pizza restaurants by the 1950s, the block was condemned in 1961 and razed a year later. Architect of the Capitol, J. George Stewart, had announced in 1958 a pressing need for more space for the Library of Congress and, within three weeks, Congress had passed a $5 million appropriation to buy the site, prompting the Capitol Hill Southeast Citizen's Association to call for his resignation.

A house at 2nd Street and Constitution Avenue NE shows the neglect of homes in Capitol Hill in the early 1960s, voiding the homes of their architectural features. Fortunately, many upwardly mobile singles began to move into neighborhood and restoration of many homes began.

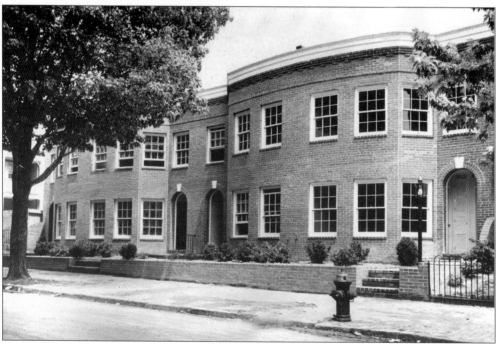

Pictured is 516 Sixth Street SE, which was remodeled in the 1960s by Dr. and Mrs. Robitscher, who were also known for their work in Georgetown and Foggy Bottom. The couple converted the building into an eight-unit rental apartment building.

These two images show the dramatic transformation of a former grocery store at the corner of Third and A Streets SE by Willard Edwards in 1963 into a period residential urban home. Such early attempts at restoration resulted in inappropriate additions, such as this early-Colonial door configuration on a Victorian commercial structure.

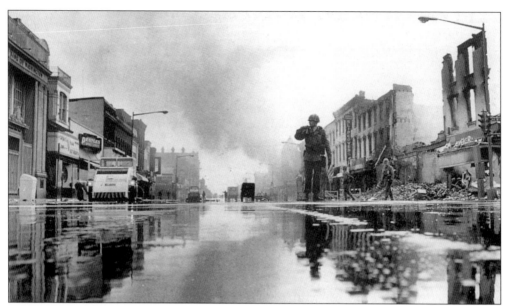

A lone soldier surveys the damage at Eighth and H Streets NE in 1968, following the riots that torched the city, including parts of Capitol Hill. The riots were primarily a result of the assassination of Martin Luther King Jr.

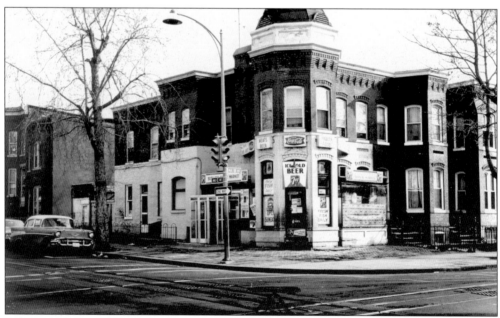

Following the riots that devastated many parts of Washington, D.C., including Capitol Hill, many homes were abandoned and replaced with ad hoc commercial buildings, such as liquor stores that targeted the lower-income residents of the area.

During President Richard Nixon's State of the Union speech on January 22, 1970, he asked members of Congress if they would dare walk the streets alone around the United States Capitol. This image, taken the following night at 9 p.m., shows that not one pedestrian was seen on Constitution Avenue.

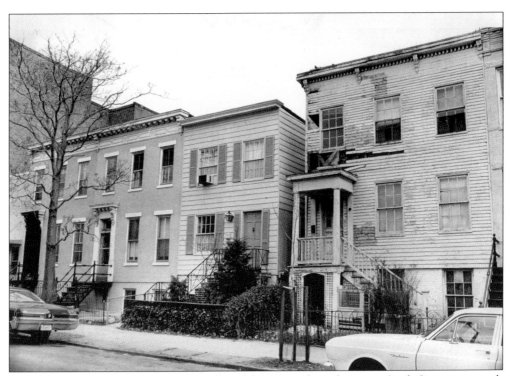

Few current homeowners in Capitol Hill could imagine that a home on Sixth Street just north of East Capitol Street, with today's escalating home prices, could have looked like this just 30 years ago.

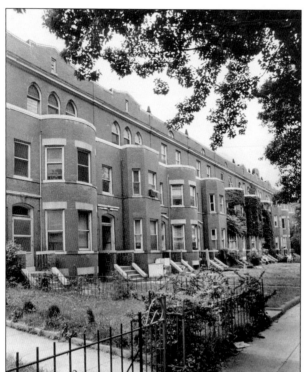

In 1973, the homes located between 312 and 338 Maryland Avenue NE, one home at 220 Fourth Street NE, and four homes at 315-321 C Street NE—all six-bedroom homes built in 1903 by a funeral home founder—were sold to a coalition of 19 families for a mere $415,000.

On June 23, 1978, a confrontation occurred at the 200 block of Maryland Avenue when a bulldozer began demolition after hours of a historic pre-Civil War home that residents had been working to preserve. Residents called the police to inspect the work permit; however, the bulldozer demolished three-fourths of the home before police could arrive.

Five

Union Station and Transportation

Myriad transportation methods, most notably the powerful railroad systems, have greatly shaped Capitol Hill's history. From the early streetcars to glamorous Union Station, transportation businesses have brought thousands of local residents and visiting tourists to the area.

One of the earliest transportation-based buildings in Capitol Hill was the Baltimore & Ohio Railroad Company's passenger station at New Jersey Avenue and C Street, which was built in 1852, but torn down in 1908 when Union Station was completed. During the time of the B&O Railroad's station, Washington, D.C. was the key transportation hub for northern troops moving south in preparation for battle in the Civil War.

Also, during this time, residents saw the coming of streetcar systems. Beginning in San Francisco, cable car systems began popping up nationwide in the early-to mid 1880s. Washington responded to the public's fascination with the streetcar system by building a cable car system on Pennsylvania Avenue from Georgetown to Capitol Hill. However, the electric streetcar system quickly replaced the outdated cable car system.

One of Capitol Hill's landmarks is Union Station, designed by Daniel Burnham, who had originally envisioned a front plaza that would mimic his well-known designs for the World's Columbian Exposition in Chicago in 1893 and the Place de la Concorde in Paris. However, due to fiscal constraints, Burnham's vision never materialized and a different design was agreed upon. Due to the moist ground on the proposed site from the remnants of Tiber Creek, workers had to spend a full year preparing the foundation.

When Union Station opened in 1907, the concourse was the largest room in the world and was built to be larger than the nearby Capitol Building. The onset of World War I and World War II brought thousands of soldiers through Union Station. During World War II, Union Station served as the nation's premier point of departure for soldiers heading off to basic training.

Tragedy struck in 1953 when the Pennsylvania Railroad's Federal Express electric train lost its brakes and slammed through the wall of Union Station, tearing a hole through the floor of the concourse. Remarkably, no one was killed. From its genesis in the beginning of the 20th century through today, Union Station remains one of Washington's premier landmarks.

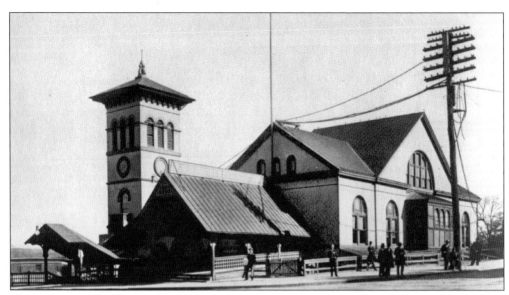

The Baltimore & Ohio Railroad Company's passenger station at New Jersey Avenue and C Street was built in 1852 and torn down in 1908 when Union Station was completed.

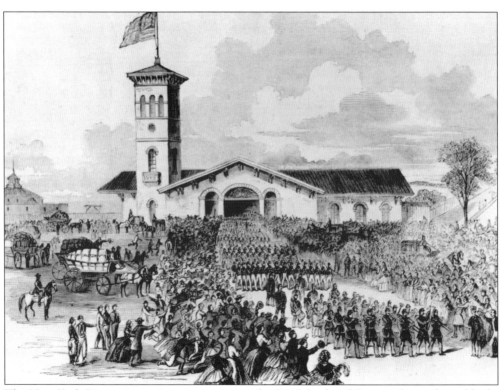

The New York 71st regiment is seen arriving at the B&O Railroad Station, located two blocks from the Capitol at New Jersey Avenue and C Street. Washington was then the key transportation hub for northern troops moving south in preparation for battle in the Civil War.

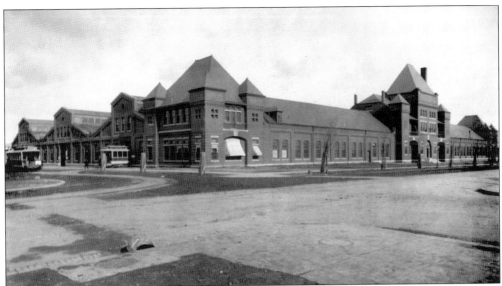

With the public's need for a faster means of transportation than by horse-drawn carriages, cable car systems began popping up nationwide in the early-to-mid 1880s. Washington's cable car system, which cost $200,000 a mile to build, began with a route on Pennsylvania Avenue from Georgetown to Capitol Hill. The electric streetcar system quickly replaced the outdated cable car system a few years later. Remnants of these prior transportation methods can be seen still today via this "car barn" in the Lincoln Park area of Capitol Hill.

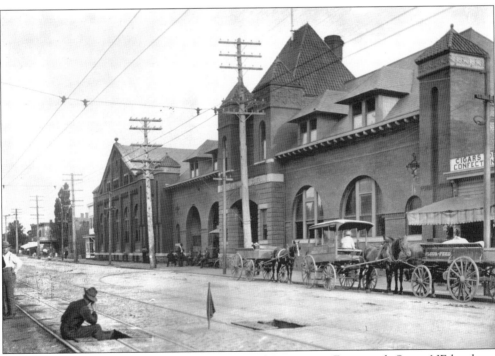

The East Capitol Street Car Barn on East Capitol Street near Fourteenth Street NE has been placed on the National Register of Historic Places and has been converted into condominiums.

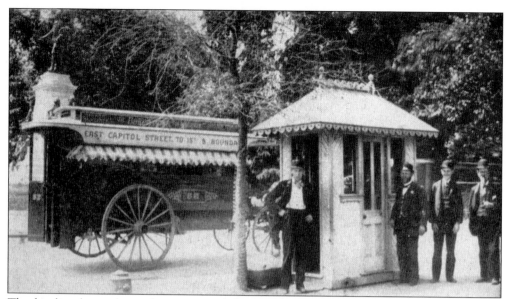

The herdics, horse drawn forerunners of the modern bus, were a major factor in the local transportation field until 1897. Designed by Peter Herdic, they seated 12 to 15 people and backed to the curb to allow people to board from the sidewalk. Pictured is a herdic that ran down East Capitol Street to Fifteenth Street and Boundary Street.

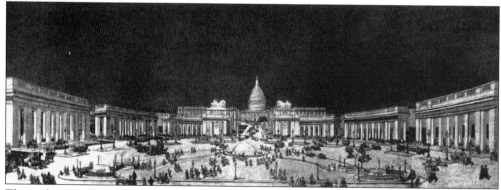

The architect of Union Station, Daniel Burnham, had grandiose plans for the front plaza that would mimic his well-known designs for the World's Columbian Exposition in Chicago in 1893 and the Place de la Concorde in Paris. He envisioned a circular grouping of buildings framing the Capitol Dome in the distance. Members of Congress and railroad executives, however, ensured that the expensive plan would never come to fruition.

The McNulty Brothers rigged up an impressive moving scaffolding to construct the enormous barrel vaulted ceiling of the main concourse in Union Station, which took two years to build, beginning in 1905. It could move along the 220-foot length of the room, providing access to the 90-foot ceiling. When completed, the room was large enough to hold the Washington Monument laid flat.

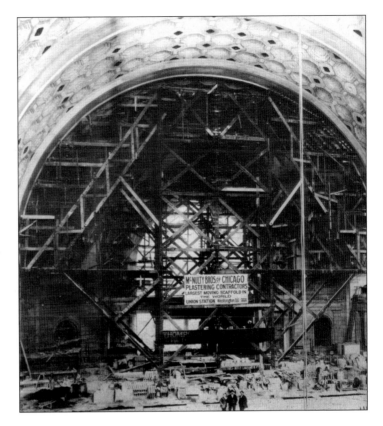

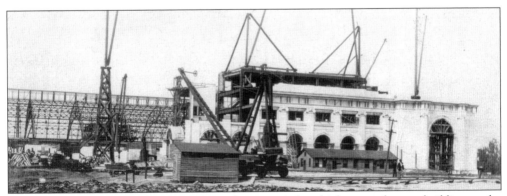

Before construction could begin on Union Station, workers had to spend a year building up the street grade and pouring concrete and close to four million cubic yards of fill dirt for the foundation, which was built on top of the moist remnants of Tiber Creek and close to "Swampoodle," a rough Irish shantytown. Burnham brought in Italian laborers to build the foundation and housed them in camps, where conflicts arose between the Italians and Irish.

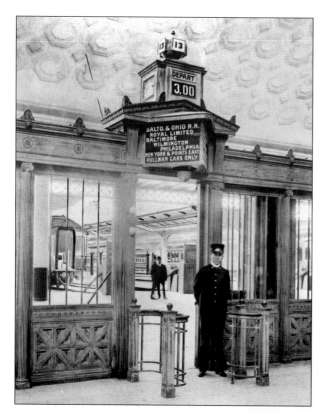

When it opened in 1907, the concourse at Union Station, which was open to train platforms, was the largest room in the world. Here, the gate manager waits to check tickets to the B&O's Royal Limited, one of its premier "Royal Blue" trains. The center portion of the gate was later relocated and is still in use for departing Amtrak and MARC train passengers.

A promotional poster for the Baltimore & Ohio's line to Chicago shows the competitive nature between the B&O and the Pennsylvania Railroad. The B&O attempted to lure passengers by suggesting that all the comforts of home could be enjoyed onboard.

SPEAKING of modern travel comforts, you can even enjoy your regular morning shower on the CAPITOL Limited *all-Pullman* to Chicago—Yes, there's a barber and valet, too.

Baltimore & Ohio
THE LINE OF THE CAPITOL LIMITED

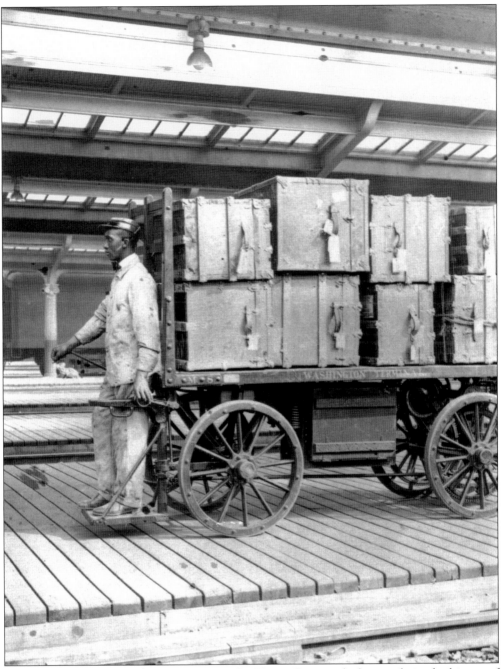

This baggage porter posed for a picture on the Union Station platform early in the history of the station when its platforms were composed of wood planks. Incredibly, his cart featured a battery-powered electric mechanism that allowed one porter to transport the heavy trunks that accompanied most passengers of the day.

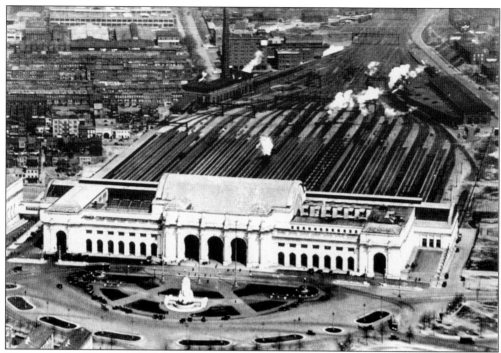

The name for Union Station was to symbolize the bringing together of Washington's two railroad lines—the Pennsylvania and the B&O. The cost to construct a tunnel under Capitol Hill to connect the southern lines mandated a $3 million federal payment.

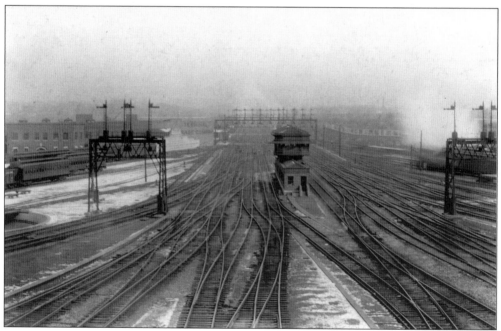

At 2:52 a.m. on Sunday, October 27, 1907, the last train left the old B&O terminal bound for Pittsburgh. The first train into Union Station also came from Pittsburgh and arrived later that same morning at 6:50 a.m.

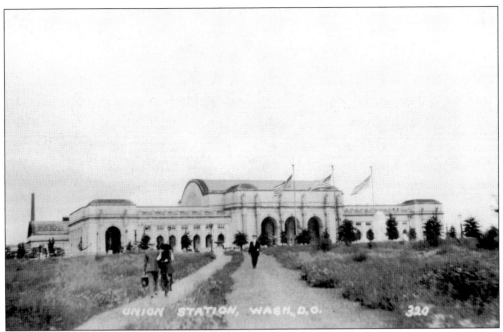

Shortly after completion, Union Station featured rural walkways leading up to the concourse, which is remarkably different than the busy concrete jungle of today where taxicabs whiz around Columbus Circle dropping off and picking up passengers. Photograph by W.R. Ross.

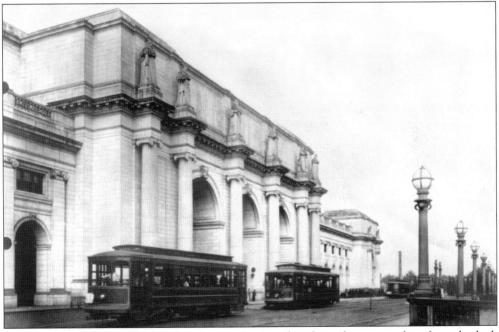

Streetcars line up outside of Union Station. Equipped with inadequate cooling fans, the lack of a sophisticated heating or air conditioning system in the enormous building created a sometimes uncomfortable atmosphere in which to travel.

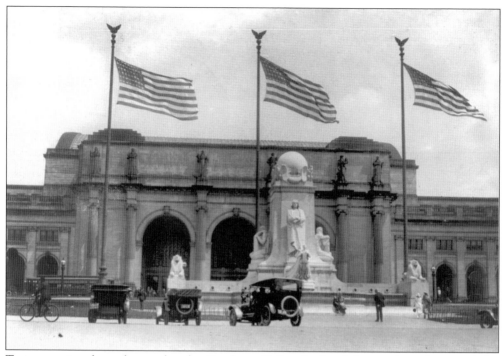

Trains coming from the south—the Southern Railroad, the Atlantic Coast line, and the Seaboard line—entered Union Station, seen here around 1920, via a tunnel under First Street.

Some of the many early features of Union Station were a central vacuum cleaning system, a system of clocks synchronized from a master clock in the third-floor telegraph office, and a large ladies waiting room seen here.

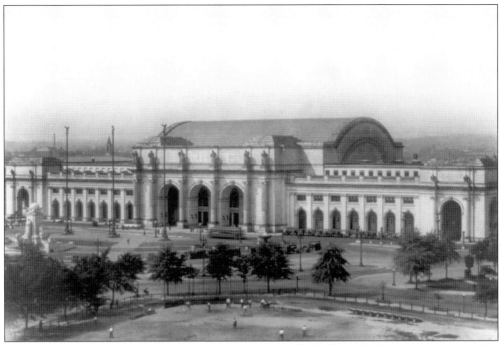

Union Station, shown *c.* 1928, is grand; it was actually built to be larger than the nearby Capitol Building. Its plaza once featured temporary housing structures built during World War I, which were used to house female defense workers.

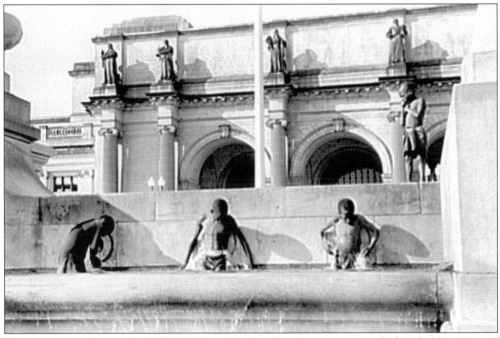

Since its completion in 1907, Union Station has become one of the focal points of Washington's ever-changing landscape. Here, some children enjoy a swim in the fountain by Union Station in 1938.

Arriving at Union Station from their private car on September 25, 1941, are the Duke and Duchess of Windsor. The duke was forced to abdicate the thrown due to his marriage to Wallis Simpson, whose mother ran a boarding house on Woodley Road in Woodley Park.

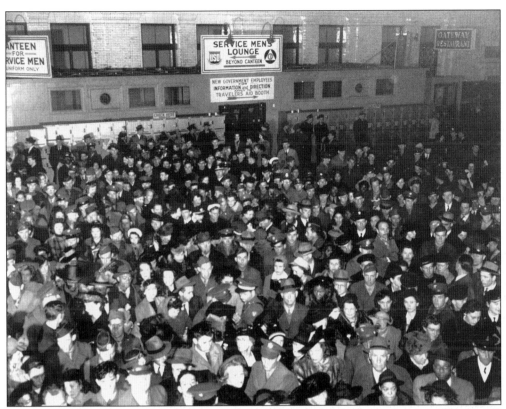

The onset of World War II brought thousands of soldiers and wartime employees to the nation's capital, swelling the city and Union Station, seen here in November 1942. The station, which was busy 24 hours a day, offered assistance to "new government employees," via the Traveler's Aid booth.

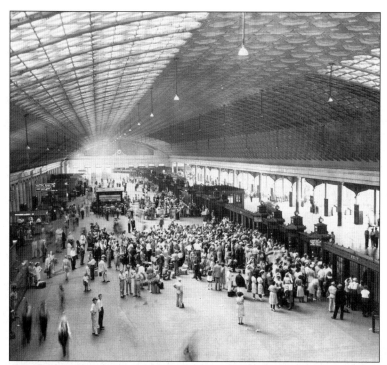

Union Station, pictured in 1941, was the principal point of departure for World War II servicemen who were heading out for basic training. The station's U.S.O. lounge took steps to ensure that sleeping servicemen were awakened for their departing trains by attaching tags to them.

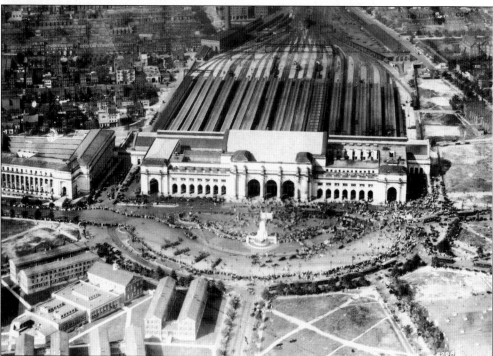

Washington residents are lined up along the streets at Union Station for the arrival of General Pershing from France. The government hotel can be seen in the left foreground and the roof of the old Billy Sunday tabernacle in the extreme right foreground. Photo by the United States Army Air Service.

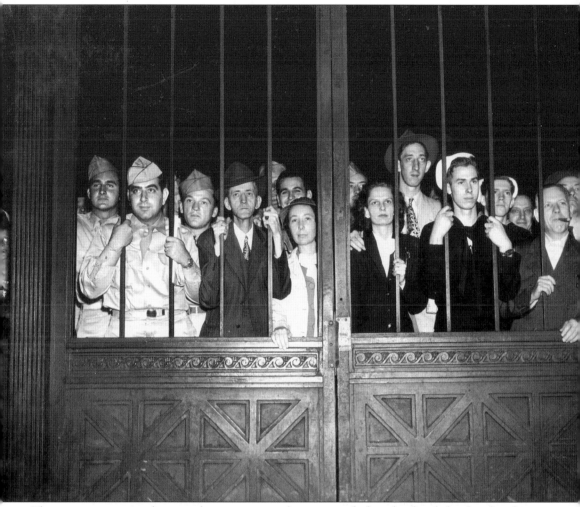

These passengers eagerly await their train just a few minutes before the dreaded railroad strike scheduled for 4 p.m. on May 18, 1946, was postponed.

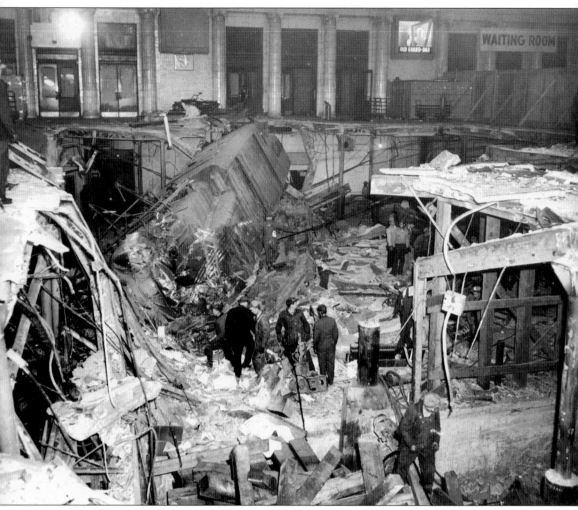

Running 18 minutes late from Boston, the Pennsylvania Railroad's Federal Express electric train lost its brakes on January 15, 1953, and slammed through the wall of Union Station, tearing a hole through the floor of the concourse. Wrecking crews lowered it from its perilous resting position, and temporary flooring was constructed and kept in place until after the inauguration of President Dwight D. Eisenhower.

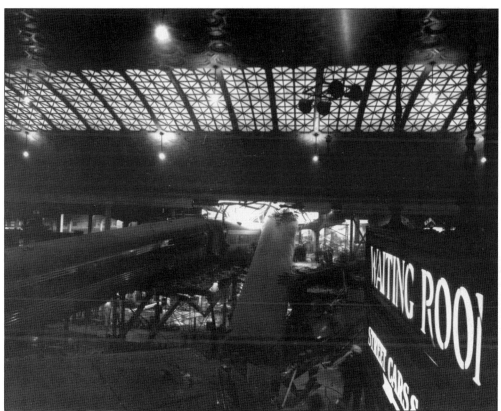

Here's another scene from January 15, 1953, also known as "Black Thursday," when a devastating train wreck shocked the 400 passengers onboard and the thousands of people in the train station, who had come to celebrate the inauguration of President Eisenhower. Amazingly, no one was killed and only 43 people were hospitalized. Luckily, when the train's 230-ton engine and two lead cars crashed into the basement, dozens of workers who would have been in the cars' deadly path were on a coffee break.

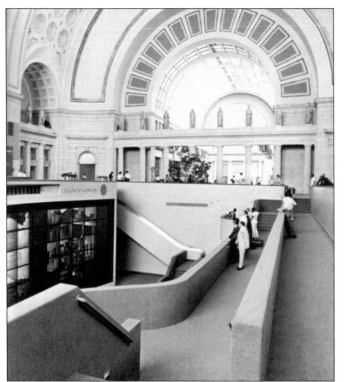

One of the ill-fated attempts at transforming Union Station into a tourist mecca included the PAVE, or Primary Audio-Visual Experience, a slide show built into a pit in the main concourse in 1988 at a cost of $1.5 million. The critics were many and suggested that tourists simply walk outside the door to view the city's historical landmarks rather than bother with the slide presentation.

This vehicle, known as a "taximeter cabriolet," awaits passengers at the west portico of Union Station in the 1920s. Many of the overnight Pullman cars were diverted to a side track if they arrived in the middle of the night and would disembark passengers in the early morning.